Michael Glover is a poet, and the visual arts critic and senior feature writer for the *Independent*. He is also the poetry editor of the *Tablet*. As an arts journalist, he has been a regular contributor to *The Times*, the *Financial Times*, the *New Statesman* and *The Economist* and a London correspondent for *ArtNews*, New York. Recent publications include *Neo Rauch* in the Lund Humphries Contemporary Painters Series.

JOHN RUSKIN

An IDIOSYNCRATIC DICTIONARY

Encompassing
his PASSIONS,
his DELUSIONS &
his PROPHECIES

COMPILED by
MICHAEL GLOVER

Other publications
by Michael Glover

Poetry:

Measured Lives (1994)
Impossible Horizons (1995)
A Small Modicum of Folly (1997)
The Bead-Eyed Man (1999)
Amidst All This Debris (2001)
For the Sheer Hell of Living (2008)
Only So Much (2011)
Hypothetical May Morning (2018)
Messages to Federico (2018)
What You Do With Days (2019)

Others:

The Trapper (2008)
Headlong into Pennilessness (2011)
Great Works: Encounters with Art (2016)
Playing Out in the Wireless Days (2017)
111 Places in Sheffield That You Should Not Miss (2017)
Late Days (2018)
Neo Rauch (2019)
The Book of Extremities (2019)
Thrust (2019)

As editor or contributor:

Memories of Duveen Brothers (1976)
Goin' Down, Down, Down: Matthew Ronay (2006)
Between Eagles and Pioneers: Georg Baselitz (2011)
Robert Therrien (2016)
Monique Frydman (2017)
John Ruskin: The Power of Seeing (2019)

Letty's Globe

When Letty had scarce pass'd her third glad year,
And her young, artless words began to flow,
One day we gave the child a colour'd sphere
Of the wide earth, that she might mark and know,

By tint and outline, all its sea and land.
She patted all the world; old empires peep'd
Between her baby fingers; her soft hand
Was welcome at all frontiers. How she leap'd,

And laugh'd, and prattled in her world-wide bliss;
But when we turn'd her sweet unlearned eye
On our own isle, she raised a joyous cry,
'Oh yes, I see it, Letty's home is there!'

And, while she hid all England with a kiss,
Bright over Europe fell her golden hair.

Charles Tennyson Turner (1880)

First published in 2019 by Lund Humphries

Office 3, Book House
261A City Road
London EC1V 1JX
UK

www.lundhumphries.com

*John Ruskin: An Idiosyncratic Dictionary Encompassing
his Passions, his Delusions and his Prophecies*
© Michael Glover, 2019
All rights reserved

ISBN: 978-1-84822-374-5

A Cataloguing-in-Publication record for this book is available from
the British Library.

Copy edited by Abigail Grater
Cover design by Alex Kirby
Typeset by Oliver Keen in Adobe Caslon Pro and Cheltenham Becker
Printed in the United Kingdom

CONTENTS

INTRODUCTION

No writer dies once. And John Ruskin, that celebrated Victorian poly-math who was born in 1819 and died in 1900 exactly a year and two days before the death of Queen Victoria, is no exception to this rule. The physical death is only a beginning, of course, because any writer hopes and expects to enjoy a healthy posthumous afterlife in the company of his many satisfied readers. And then, sooner or later, there may come the death of the reputation of that once living person, the death of all that was once embodied in his or her once influential writings.

Some writers live on forever of course, gloriously self-renewing – Dante, Shakespeare and Plato, for example. As for all the rest, at a certain point the presses stop turning, and the second-hand book dealers quietly remove all that remains. And, day by day, in the coming months and years, the antiquarians pop by to gather up the opinions of yesterday. We now call such people cultural and literary historians. Their job is to give pretend life to what is profoundly dead in order to sustain themselves in a job.

But surely Ruskin could not die! By the time that Ruskin's body failed him in 1900 after years of sorry mental decline, benignly incarcer-ated in his bath-chair at his home beside Coniston Water in the Lake District, tended to by his cousin Joan Severn (whose father Joseph had looked after the ailing John Keats at the end of *his* life), there was no expectation that his writings and his reputation would die any time soon.

On the contrary. His friend George Allen was publishing Ruskin's books in popular editions with print runs running into their thousands.

Most respectable homes would have had their small, leather-bound set of Ruskins, which would probably include: *Modern Painters, The Stones of Venice, Unto This Last, The Seven Lamps of Architecture* and much else. These books were cornerstones of any respectable household. They were almost as much a part of the intellectual currency of the Protestant middle classes of England as the Bible or the Book of Common Prayer had been. And then, all of a sudden, Ruskin disappeared. He became an anachronism, a thing as curious and remote as a clay pipe at the bottom of a stream.

Why did this happen? What was it that caused Ruskin to disappear when other great Victorians continue to speak to us, even today, with great urgency?

After his death, his collected works were published in 39 volumes. They were a flop from a sales point of view, more a tombstone than a monument. His remote verbosity, his florid language, stuffed with the confidence of empire, felt utterly alien, wholly opposed to the pared-back language of modernity. His preacherliness, all this earnest talk of nobility and beauty, seemed somewhat alien in a brave new world of bitter conflict. The man, too, was at fault for having been himself. His sexuality was put under scrutiny. His opinions of women were those of a man of yesteryear. Had he not declared his undying love for a girl of barely ten, and finally gone mad after she rejected him? His views on race and empire seemed wholly anachronistic and utterly reprehensible.

And so, in the aftermath of the most destructive war that the world had ever experienced, his reputation withered. Ruskin came to seem like a remote, lost-in-sepia Victorian eminence with whom the pessimism of the present would henceforth have little to do. He was too pious, too moralistic, altogether too remote from our concerns.

And now the world, having turned, has turned again. The celebration of his bicentenary has helped us all to recognise that Ruskin has much to say to us, still – about our custodianship of the world, the well-being of

man and woman, and much else. He regarded the earth as his friend and teacher. Ruskin is thus also our contemporary, and this dictionary is an attempt to reveal both the man himself as he was then – what he thought and felt and said, warts and all – and a little of what he might mean to us now. As he expressed it in a celebrated sentence from *Modern Painters*: *The things to be desired for man in a healthy state, are that he should not see dreams, but realities; that he should not destroy life, but save it; and that he should not be rich, but content.*

A TIMELINE

of

JOHN RUSKIN'S LIFE AND LEGACY

KEY

events in the life of Ruskin: roman
historical and cultural context: italics

1819
Born in London, the son of John James Ruskin, a wealthy
sherry merchant, and Margaret Cox.
*The Peterloo Massacre in Manchester – 18 people die at a gathering
in support of Parliamentary reform.*
Birth of Queen Victoria.

1832
Receives Samuel Rogers's *Italy* as a gift. Its illustrations by
J.M.W. Turner help shape his artistic thinking.

1833
Makes the first of many extended tours of Europe.
Each one heavily influences his art and writing.
*Factory Act limits children's working hours and establishes
regular inspections.*

1837
Becomes gentleman-commoner at Christ Church, Oxford.
Queen Victoria ascends to the throne.

1839

Charles Dickens's novel Oliver Twist, *a favourite of Ruskin's, is published.*

1842

Graduates from Oxford with a fourth-class degree at the age of 23.

1843

First volume of *Modern Painters* establishes Ruskin's reputation as an art critic.

1848

Karl Marx and Friedrich Engels' Communist Manifesto *is published.*

Year of revolutions in Europe.

1849

Publishes *The Seven Lamps of Architecture*, which considers the emotional and ethical power of building.

1851

Publishes the first volume of *The Stones of Venice*, analysing the role of society within cultural achievement.

Begins patronage of the Pre-Raphaelites.

1854

Begins teaching at the Working Men's College, London, which provides vocational instruction to workers.

1860

Produces *Unto This Last*, a collection of essays criticising capitalist economy; initially serialised in the *Cornhill Magazine*, then published as a book in 1862.

1869

Becomes Slade Professor of Fine Art at the University of Oxford. He resigns in 1879, resumes the post in 1883, then resigns again in 1884 in protest at vivisection.

1871

His papers of social commentary, *Fors Clavigera: Letters
to the Workmen and Labourers of Great Britain* first appear –
the origins of his Guild of St George.

1875

Opens his St George's Museum in Walkley, Sheffield.

1876

Suffers from severe depression. Attacks continue to interrupt
and influence his working life.

1878

Sued by artist James Abbott McNeill Whistler for a negative
critique. Ruskin loses, but is fined one farthing, thus
bankrupting Whistler.

1887

The standard English translation of Karl Marx's Das Kapital
(1867) is published.

1888

Last European tour.

1900

Dies at Brantwood, his home on the shores of Coniston Water
in the Lake District.

1906

Marcel Proust translates The Bible of Amiens *by Ruskin
into French.*

*29 Labour MPs elected to the House of Commons for the
first time. Which book had influenced them most profoundly?*
Ruskin's Unto This Last.

1908

Mahatma Gandhi translates Unto This Last *by Ruskin into
Gujarati under the title of* Sarvodaya *(Universal Uplift)*

A NOTE ON THE
DICTIONARY ENTRIES

Passages of text set in italics are direct quotations,
sources of which are indicated within or at the end
of the entry. The following abbreviations are used
for those from Ruskin's own writings:

The Crown of Wild Olive: CWO
Fors Clavigera (1896 edition): *FC*
Hortus Inclusus: HI
Letters to Charles Eliot Norton: CEN
The Library Edition of the Works of John Ruskin: LEJR
Modern Painters: MP
Praeterita: PRAE
Pre-Raphaelitism: PRE
The Queen of the Air: QA
The Seven Lamps of Architecture: SLA
The Stones of Venice: SOV
The Two Paths: TP
Unto This Last: UTL

An
IDIOSYNCRATIC
DICTIONARY

Aesthete As a very particular dresser, yes, you could call Ruskin an aesthete, if not something of a dandy. His style of dress went through three quite distinct phases. When at Oxford as a gentleman-commoner in 1841, a portrait by Thomas Richmond shows that he then favoured modishly tight, flesh-coloured trousers, swallow-tail coat with gold and red lapels, and a high black neckcloth. Behind him, you can see his tasselled cane and stove-pipe hat. Later on, he came to epitomise Victorian respectability in frock coat and blue neckcloth – he was famous for his brilliant blue neckcloths, wound round and round and round his neck. (His eyes were blue too.) The third phase saw him wearing clothes made out of indestructible homespun cloth from the Isle of Man, respectability of a more rural kind. He loved his waistcoats to have four pockets. To beard or not to beard was a matter of acute interest to Ruskin's father (see **Father**), who intensely disliked beards. *I do hope you will always be able to keep a smooth face*, he had growled at his son in a letter of 1852, *for I never see a man (not a Jew or a Soldier) with Hair on his face that I do not set down as an idiot*. Ruskin, ever the dutiful son, did not grow one until 1881, by which time his father was long dead. On his clothes Ruskin spared no expense. In 1887 his valet Peter Baxter grew so anxious about the sums his master was proposing to spend at a tailor's in Paris that he reported his financially wayward behaviour back to his cousin and carer-in-chief, Joan Severn. The bill for four top coats and five waistcoats easily exceeded the annual wages of the household cook. In other respects, Ruskin was no aesthete at all. There was no such thing as Art for Art's Sake, a doctrine espoused by Walter Pater, also an Oxford man. Art was a product of social relations.

Alone with a Friendly Picture *Men are more evanescent than pictures, yet one sorrows for lost friends, and pictures* are *my friends. I have none others. I am never long enough with men to attach myself to them; and whatever feelings of attachment I have are to material things. If the great Tintoret*

here were to be destroyed, it would be precisely to me what the death of Hallam was to Tennyson – as far as this world is concerned – with an addition of bitterness and indignation, for my friend would perish murdered, his by a natural death. Hearing of plans for its restoration is just the same to me as to another man hearing talk behind an Irish hedge of shooting his brother.

Letter to his father, 28 January 1852

America In spite of the fact that Ruskin never visited America, he had very strong opinions about the place, which he often shared with his friend and American correspondent Charles Eliot Norton. His pity for its benightedness was almost unbounded. He had seen a number of landscape paintings by an American painter of some repute, he reported, and their ugliness was quite *Wonderful*, which led him to conclude that the ugliness of the country itself must be *Unfathomable*. He knew all about its *over-hopefulness* and *getting-on-ness*, its *atmosphere of calculation* (see **Money**) and the *very sense that nobody about you is taking account of anything, but that all is going on into an unspelt, unsummed, undistinguished heap of helplessness.* Fortunately for Ruskin, he actually had the opportunity of observing a real American family during an Italian journey in August 1869, and he was at last able to analyse their limitations from very close quarters indeed. *I was fated to come from Venice to Verona with an American family, father and mother and two girls – presumably rich – girls 15 and 18. I never before conceived the misery of wretches who had spent all their lives in trying to gratify themselves. It was a little warm – warmer than was entirely luxurious – but nothing in the least harmful. They moaned and fidgeted and frowned and puffed and stretched and fanned, and ate lemons, and smelt bottles, and covered their faces, and tore the cover off again, and had no one thought or feeling, during five hours of travelling in the most noble part of the world, except what four poor beasts would have had in their den in a menagerie, being dragged about on a hot day. Add to this misery every form of possible vulgarity, in methods of doing and saying the common*

things they said and did. I never yet saw humanity so degraded . . . Given wealth, attainable education, and the inheritance of eighteen centuries of Christianity and ten of noble Paganism; and this is your result – by means of 'Liberty'. And then there was the little issue of American pirated editions (see **Piracy**).

CEN, vol.1, pp 27–8 and 218–19, letters of 28 December 1856 and 9 August 1869

Anachronism Was Ruskin an anachronism – as *Vanity Fair* accused him of being in 1870? Of course he was. Of course he wasn't. He was out of key with his times, certainly. He deplored steam power. He hated the railways for slashing their brutal iron blade through the tranquil beauty of the English countryside. He much preferred to travel for weeks by coach from London to the Lake District along the oldest and most challenging of coaching roads with his books, those necessary companions, in a bath on the roof, a chess set on his knees, and a drawing pad in his pocket. He could not abide the idea that it might be entirely legitimate for a man to wish to be speedy. He thought that cycling (see **Cycling**) was a preposterous thing for a sensible biped to be doing – he himself (like the poet Wordsworth before him) was a great walker. And yet this most anachronistic of bipeds could also see deep into the future. He made apocalyptic-like warnings about the consequences of industrial pollution in the 1870s. His passionate defence of Nature in all her glorious fragility strikes a chord with us now. His desire to be mindful of man as a whole being, not merely a soulless, toiling machine, anticipates the thinking of our own time. His crazed, multi-directional musings are still very much in play. He is a bewhiskered, sepia-lost anachronism who still deserves to be listened to.

Animals, Being Kind To In 1885 Ruskin, a believer in the need to show animals the respect that was their due, founded the Society of Friends of Living Creatures. Though its president, he preferred to be

known as Papa. The members, children of either sex from the ages of seven to fifteen, had to pledge not to shoot, harm or mercilessly tease. Animals were there to be befriended, drawn, studied or merely closely observed for their unusually characterful and often comical habits (see **Birds**). To hunt them down in cold blood was an act of unspeakable barbarity (see **Viper**).

Annulment of his Marriage Was it a wholly unhappy marriage, the short one (four years) between Ruskin and Effie Gray (see **Gray**)? Her letters written from Venice between 1849 and 1852 seem to suggest at least a modicum of contentment – in spite of the fact that she spent so much time without him, in the company of female companions, because he worked so obsessively, and had no wish to socialise whatsoever. He much preferred the companionship of a book. She loved nothing better than to dance, and to observe, and then record in minute detail, the sartorial habits of others – pretty countesses, the extravagantly handsome and well-bred Austrian soldiery. His parents were fussily oppressive, too. Did Effie spend too much of his (or perhaps their) money on clothes? Even more than Ruskin himself spent on cumbersome casts of capitals for shipping back home, or when indulging his mania for buying old books? And yet, when the end came, the marriage was annulled on the grounds of non-consummation. Had he been unable after all? Or was the reason for it his declared hatred of the idea of children? Or does the story that he was horrified by the sight of pubic hair on a live female (see **Pubic Hair**) have any credibility? Did it strike him impotent, the sight of her unclothed on their wedding night, having known only hairlessly idealised representations of the feminine form on the walls of public galleries until that moment? After all, he had been an only child. Nonsense, say many. All tittle-tattle. And so, she fell into the arms of the Pre-Raphaelite (see **Pre-Raphaelites**) painter John Everett Millais (see **Millais**). Within a month of the annulment of the marriage,

Ruskin, as his diary records on 13 August 1854, seems to have been in a mood of unencumbered bliss. *How little I thought God would bring me here again just now – and I am here, stronger in health, higher in hope, deeper in peace, than I have been for years. The green pastures and pine forests of the Varens softly seen through the light of my window. I cannot be thankful enough, nor happy enough.* Psalm LXVI, 8–20. When Nature and the Deity can offer such a broad range of consolations, who needs a wife?

The Diaries of John Ruskin, ed. Joan Evans, vol.2, p.500

Appearance Ruskin was much taken by his own appearance, and much regretted when the image did not quite match the aspirations of the man. *I like to be flattered*, he once wrote, *both by pen and pencil, so it can be done prettily and in good taste.* Thomas Carlyle (see **Carlyle**), seeing him in 1850, described him to his brother as a *small but rather dainty dilettante soul, of the Scotch-Cockney breed.* Charles Eliot Norton, meeting him for the first time in 1855 when Ruskin would have been 36 years old, wrote of *his abundant light-brown hair, his blue eyes, and his fresh complexion, which made him look young for his age.* His figure was slight – he remained ten stone until almost the end of his life – his movements quick and alert. William Michael Rossetti, brother to Dante Gabriel (see **Rossetti**), remembered him as *exceedingly thin (I have sometimes laid a light grasp on his coat-sleeve, and there seemed to be nothing inside it).* There was no reserve, no stiffness or *hauteur* about him, no self-consciousness, no recognition of himself as a man of distinction, *but rather, on the contrary a seeming self-forgetfulness and an almost feminine sensitiveness and readiness of sympathy.* His voice was light, if not high, and he spoke with a mild Scots accent. He dressed like an aesthete (see **Aesthete**), habitually wearing a brilliant blue neckcloth which matched the colour of his own eyes, and took a keen interest in how he looked in photographs, even in extreme old age. The bearded old man he stared back at in an image from the Brantwood years (see **Brantwood**) truly appalled him. *They've been*

doing photographs of me again, he wrote in 1887, I'm an orang-utang as usual, and am in despair. I thought with my beard I was beginning to be just the least bit nice to look at . . . I would give up half my books for a new profile. He appreciated the difficulty of the task of looking up to scratch quite early on. The *right ideal is to be reached . . . only by the banishment of sin upon the countenance and body.*

W.M. Rossetti, *Some Reminiscences*, vol.1, p.177, and *MP, vol.2, pt.3, section 1, ch.14*

Architecture Old buildings had an aura of sanctity about them, according to Ruskin. He believed that they should not be touched or restored – there was no viler a word in Ruskin's vocabulary – because they are not ours to meddle with. They are priceless. We read the lessons of history in their stones, their sculptural embellishments. Much of his anguish, lifelong, was due to the fact that these untouchable, irreplaceable buildings (often fine specimens of Gothic architecture from the Middle Ages – see **Gothic**) were being destroyed, wantonly, everywhere he looked, by those restorers or, just as bad, *revolutionists*. After writing the first of several volumes of *Modern Painters (see **Modern Painters***) as a freshly graduated young man in defence of the reputation of the widely vilified J.M.W. Turner (see **Turner**), he turned his attention to architecture, and the title of the book he wrote in explication of his principles, *The Seven Lamps of Architecture* (1849), has a rather off-putting odour of sanctity about it, as if the subject of architecture were a temple that one would be wise to approach on one's knees. He later called it a wretched rant of a book, but that is to do him less than justice – he was often hard on his younger self. Although the book is often skewed by its tedious moralising, his analysis of the form, texture and decorative versatility to be discovered in any close analysis of the Gothic architecture of the Middle Ages, had an extraordinary freshness and intellectual sprightliness about it. He owes a small debt to a book written by Augustus Pugin almost two decades before, but it is a debt that Ruskin

would never have stooped to acknowledge, such was his contempt for the man (see **Houses of Parliament**). In fact, he lied when he said that he did not read Pugin.

Aristocracy Ruskin rubbed up against many aristocrats when a gentleman-commoner at Christ Church, Oxford (see **Oxford**), and then in later life too. In the early 1860s he roughed them up badly for mistreating their workforce in a book called *Unto This Last* (see *Unto This Last*). Reliable anecdotal evidence suggests that a gang of swaggery toffs challenged him to a drinking session in college, expecting to humiliate with relative ease this rather dainty-looking, curiously light-of-voice, bookish aesthete. They had not reckoned on Ruskin's solid background in polite quaffing when at home in Herne Hill, south of London. Given that he had been accustomed to having alcohol at the table since childhood (after all, his father was a very successful sherry merchant – see **Father**), he had no trouble in drinking them under the table. The toffs were so impressed by him that they gave him a peek at their pornographic drawings. He had proved himself to be one of the boys after all. This is what he said, in a sniffy, high-minded bout of moralistic fury, of this feckless, boorish lot: *They were men who had their drawers filled with pictures of naked bawds – who walked openly with their harlots in the sweet country lanes – men who swore, who diced, who drank, who knew* nothing *except the names of racehorses – who had no feelings but those of brutes – whose conversation at the very hall dinner table would have made prostitutes blush for them – and villains rebuke them – men who if they could, would have robbed me of my money at the gambling table – and laughed at me if I had fallen into their vices – & died of them.* Needless to say, he avoided the European aristocracy like the plague when in Venice between 1848 and 1852, spoke to very few, and immediately forgot such ones as he met, as the ever gregarious Effie (see **Gray**) reminds us in her letters, lashing out at him scornfully for hiding his face beneath a photographic hood

when in St Mark's Square. Why waste time talking to overdressed, over-entitled fools when there was a great deal of solid looking and thinking and snapping to be done? – Ruskin might have responded, had he possessed the good grace to show his face.

Kevin Jackson, *A Ruskin Alphabet*, p.56

Art Critic Ruskin fell into art criticism because of the work and the electrifying example of just one man: the painter J.M.W. Turner (see **Turner**). Like Turner, Ruskin was not to be deflected from his course. Like Turner, Ruskin had ferocious powers of intellectual application. And yet it was all his other intellectual and emotional preoccupations, his multifarious inquisitiveness – from geology to botany, from etymology to mineralogy, from rambling through Alpine landscapes (with plumb line and tape measure and drawing pad in capacious pockets) to the poetry of Dante and the Troubadours – which helped to turn Ruskin into the unique figure that he became in the world of art criticism. Ruskin looked closely at everything that engaged him. He was never satisfied by approximations or generalisations. When he described something – even if it were it a mediocre drawing in the Royal Academy's Summer Exhibition – he looked at it and analysed it with dogged exhaustiveness. He drew in lessons from all his other outside interests. He simply would not let a work of art go until it had been entirely ransacked, every virtue, every last, small limitation exposed to view, with merciless accuracy. The consequence of this exhaustive analytical approach can be wearisome at its worst, bad poetry misplaced. It is seen at its very best in some of his descriptions of the landscapes of Turner. No one has risen in defence of an under-sung hero as Ruskin reared up like St George himself in defence of Turner. Turner said almost nothing back to Ruskin. He was a notoriously taciturn man. Ruskin must have rendered him speechless by his interminable flourishes of singing rhetoric. And yet Ruskin also fell badly short as an art critic in various important

respects. His prudishness and his passionate attachment to the Bible hobbled him in his early years. His curt and high-handed dismissal of paintings on the grounds that their subject matter was not sufficiently noble, his hatred of the low-life scenes of the great Dutch painters of the 17th century (see **Dutch Painting**), strike one as comically inadequate now, almost old-maidishly prudish.

Artist Ruskin never regarded himself as a true artist at all. He was an amateur at the game, a humble toiler in the vineyard. His works were often unfinished, preparatory works or teaching aids, details from some greater whole that he would never have wished to coax into being. He was not necessarily interested in finality. His keen eye would home in on a fragment, and that would be more than enough. He would often emphasise the difficulty of wrestling with a drawing or *confess . . . my evermore childish delight in beginning a drawing; and usually acute misery in trying to finish one. People sometimes praise me as industrious, when they count the number of printed volumes which Mr. Allen* [his publisher, engraver and friend] *can now advertise. But the biography of the waste pencilling and passionately forsaken colouring, heaped in the dusty corners of Brantwood, if I could write it, would be far more pathetically exemplary or admonitory.* Ruskin worked in the service of art, striving to understand, and to cause others to understand, why art was so important, what role it served in society, why man should revere it when at its best. What he did best was small things: the shape and the form of a particular leaf in all its uniqueness, or the delicate tracery of a peacock's feather (see **Audubon and Other Feathered Friendships**), so tenderly and entirely coloured – tender was an adjective of high praise from Ruskin. In other respects, he could be a rank amateur. His preparation of his paints could be inept. A curator of the Ruskin Museum in Coniston has told of how, when a small Ruskin landscape returned from an exhibition elsewhere, large sections of white pigment from sky and clouds had disappeared

altogether. The great art critic, he who knew so much about the subject matter of paintings, he who could read the stones of the cathedral of Amiens like a book, could make a real hash of things when it came to mixing his whites.

PRAE, pt.2, ch.7, 'Macugnaga', section 136

Audubon and Other Feathered Friendships Ruskin greedily assembled many handsome, leather-bound volumes filled with prints of exotic birds, and then donated them to his new museum in Sheffield (see **St George's Museum**) so that working men and women could become acquainted with some of the world's strangest wonders. He also bought single illustrations by the likes of his exact contemporary Edward Lear, and others by John James Audubon, that master of botanical illustration from America. He liked nothing better than to go to the zoo with Henry Stacy Marks, who had the gift of being able to capture the odd behaviour of the birds that he was drawing – the clod-hoppingness of a pelican, for example – with more than a dash of humour. A real bird (see **Birds**) was so much more satisfactory a subject of contemplation than a stuffed one, thought Ruskin, who gloated *like a good vulture* over Marks's drawings. One of Ruskin's finest watercolours shows the fan-like spread of the tail feather of a peacock. Trying to capture its glorious iridescence was akin to bottling a bit of the hue of heaven itself. His humorous cast of mind, when he stepped down from the pulpit, was also perfectly aligned with Lear and his limericks. *I really do not know any author to whom I am half so grateful for my idle self, as Edward Lear. I shall put him first of my hundred authors*, Ruskin wrote in the *Pall Mall Gazette* of February 1886. There were always so many Ruskins. One of them evidently walked hand in hand with 'The Dong with the Luminous Nose'.

Baby Was he ever a baby? Or did this mighty brain spring forth from the womb fully formed and ready to wrestle down the world?

There is a chest of drawers in Ruskin's modest bedroom at Brantwood (see **Brantwood**) in the Lake District, which contains his christening bonnet and gown, all prettily flounced and tucked. His first portrait was painted by James Northcote when he was three-and-a-half years old and, as Ruskin himself puts it in his late autobiography *Praeterita* (see **Praeterita**), it shows *a very pretty child with yellow hair, dressed in a white frock like a girl, with a broad, light-blue sash, and blue shoes to match; the feet of the child wholesomely large in proportion to its body; and the shoes still more wholesomely large in proportion to the feet.* Having sat in silence with the painter in his studio for ten minutes, the child asked why there were holes in the carpet. He had been sitting there contentedly, counting them. This painting by Northcote occupied pride of place over the fireplace in the dining room during Ruskin's lifetime. When the contents of the house were sold off at Sotheby's in 1931, the picture was sold, and eventually found its way into the hands of a dealer in Madison Avenue, New York, called H.B. Yotnakparien. Ruskin's lot had fallen so far by this time that when Yotnakparien re-sold the portrait, it changed hands as a *dog painting*. Now it is back at Brantwood, in its old position of pride, flanked by portraits of his parents. Most visitors give more attention to the child once again, though the dog is *not entirely contemptible*, as Ruskin might have said, had he been asked.

Badgers, Theology of *That badger's beautiful. I don't think there's any need for such beasts as that to turn Christian.*

HI, p.118

Baby language Ruskin had a bizarre habit of using baby language in his letters, and most frequently in those addressed to his young Scottish cousin and housekeeper Joan Severn (he wrote three thousand letters to her alone), who looked after Brantwood in the Lake District, busily ordering workmen to rebuild the house at the Master's expense as her

own family grew and grew, when Ruskin went wandering – he was for-
ever a restless wanderer. Why so much baby language though? Perhaps,
having been so pampered and fawned over by his mother (see **Mother**),
and never having had a happy relationship with any living woman (see
Women) – although his wife Effie (see **Gray**), when in Venice, was very
much aware of how much he loved to have pretty young French girls
around as housemaids – he would remain forever the child-man, never
quite able to grow up. When in Sheffield in 1879, he stayed with a master
carpenter and his wife in a pinched terraced house on a hillside. Ruskin
reports nothing of their conversation – perhaps there was none – but he
does wax lyrical about the quality of the breakfast he was given in a
touching stream of rather bibbly-babbly nonsense – far removed from
the orotundities of his official prose (and pose) as a mightily judgemental
art critic and analyser of the misdeeds of employers. *[M]e's to have Wilt-
shire bacon for bek,* he splutters and sputters hysterically, *– oo dee-di, wee
piggy-wiggie – Bacon as pink as salmon! – di ma with balmy fat – and it's
toasted before the fire on a fork like real toast – and it makes me think of
Hernehill bacon – as of so much dead oak-leaves frazzled with greasy cinders.
And they've got such Cheshire cheese – just the colour of one of Arfie's fiery sun-
sets – and all crumbly – Crumbles Roy all to nothing!* Could a man as silly
as this truly regard himself, or expect to be taken seriously, as the keeper
of the nation's conscience?

Letters to Joan Severn, 17 and 18 October 1879

Baroness Duquesne (née Adèle-Clothilde Domecq) In Ruskin's
own words, *she reduced me to a mere heap of white ashes in four days.* His
first tragic, unconsummated love affair (if it can be so called) at the
tender age of 17 was with Adèle Domecq, one of the four daughters of
a man whose grapes provided the wherewithal to make the sherry im-
ported by Ruskin's father (see **Father**), thus guaranteeing the prosperity
of the Ruskin household. This man was Pedro Domecq, one of John

James Ruskin's business partners. Unfortunately, the Domecqs, being Spanish, were Catholics, which was quite beyond the pale. John suffered a bit of a psychological collapse when the relationship (if it can be so called) concluded messily, but some years later he encountered the woman again, in Venice, and by this time she had become Baroness Duquesne. *John's former Belle* – as Effie describes her, somewhat icily, upon spotting her at a concert given there by Offenbach – was *much the plainest of the whole of them, and . . . much disfigured by a violent cold and inflammation of the eyes*. This bell tolled hollowly, alas. Ruskin's attachment to Adèle had been headlong, rash, a case of a mere impulsive child of a man being dragged along by his feelings, as he acknowledged in later life. *The entirely inscrutable thing to me, looking back on myself, is my total want of all reason, will, or design in the business: I had neither the resolution to win Adèle, the courage to do without her, the sense to consider what was at last to come of it all, or the grace to think how disagreeable I was making myself at the time to everybody about me. There was really no more capacity nor intelligence in me than in a just fledged owlet, or just open-eyed puppy, disconsolate at the existence of the moon.*

PRAE, pt.1, ch.10, 'Quem Tu, Melpomene', section 210

Becoming a Painter: A Few Tips It was never sufficient for Ruskin to concentrate on the dissection of a single painting when he made his fierce annual appraisals of the works in the Royal Academy Summer Exhibitions (see **Royal Academy**), first sold as pamphlets out on Piccadilly so that any passers-by could hold a sharp Ruskinian view too. As one of nature's natural pedagogues, he also felt obliged to give more general advice to whoever might be prepared to listen. Sometimes this advice was unusually positive. *Young painters must remember this great fact, that painting as a mere physical exertion, requires the utmost possible strength of constitution and of heart. A stout arm, a calm mind, a merry heart, and a bright eye are essential to a great painter. Without all these he*

can, in a great and immortal way, do nothing . . . Frequent the company of right-minded and nobly-souled persons; learn all athletic exercises, and all delicate arts; music more especially; torment yourself neither with fine philosophy nor impatient philanthropy – but be kind and just to everybody; rise in the morning with the lark and whistle in the evening with the blackbird; and in time you may be a painter. Not otherwise.

PRE, p.244

Bible, The As a child, there was no book more important to Ruskin than the Bible. His mother (see **Mother**) had him memorise large tracts of it. *As soon as I was able to read with fluency, she began a course of Bible work with me, which never ceased till I went to Oxford. She read alternate verses with me, watching, at first, every intonation of my voice, and correcting the false ones, until she made me understand the verse, if within my reach, rightly and energetically . . . In this way she began with the first verse of Genesis, and went straight through, to the last verse of the Apocalypse; hard names, numbers, Levitical law and all; and began again at Genesis the next day.* His early books on art and architecture are spattered with Biblical quotations, full of the thunderous orotundities of the King James Version of 1611, almost as much a species of soap-box oratory as anything more secular. Can these arcane references be understood by us now? Often not, especially when he is citing some of the lesser books of the Old Testament. It would have been a little easier for his readers in Victorian England, of course. The Bible would have been their bedside reading too, common currency, tucked in beside the flickering candle. Evangelical Christianity was Ruskin's meat and drink until he spat it out as he approached the age of about 30 (see **Year 1858**). The entire world was a manifestation of God's love, God's grace, God's generous, uncontrollable meddling. Then, at a certain critical point in Ruskin's life, Nature turned dark and unwholesome on him. It no longer embraced him. It even turned a little poisonous to behold. Was this a

problem to do with the outside world or the troubled nature of this particular inner man? A little of both perhaps.

PRAE, pt.1, ch.2, 'Herne Hill Almond Blossoms', section 46

Birds As Ruskin aged, his prose became more readable, less convoluted, less like a series of official pronouncements delivered from a great height, and perhaps even a little more vulnerable. He began to sound a little less like a man on his mettle, and a little more like the intimate and delightful letter writer he could be from time to time. *Love's Meinie*, a book published in 1873, written in part as a manual of instruction, and based on a series of lectures that he had delivered at Oxford about the birds of England and Greece, is frisky, fanciful, and somewhat bird-like in the way that it hops about like . . . well, yes, like a bird perhaps. He begins by thundering against huntsmen – he hated their barbarically destructive behaviour. There has been a neglect of bird study because they are good only to be killed, he informs us, this most judgemental of men. His object will be to instil a sense of respect for birds by naming, studying and classifying them. And then he settles in to a mode of address that feels almost fondly child-like in its intimacy. *To paint a bird will make the heart kinder and a little happier*, he tells us, as if starting on a nursery rhyme. He springs oddly fanciful surprises. A robin reminds him of one of his favourite authors, Charles Dickens. How? we wonder. Solitary wanderers of the highways and byways, they both enjoy going about on their own at nights. And then he delights us by defining a bird's beak comically, describing to us the various ways in which it is useful. It is a sword, a tool-box, a dressing-case, a pocket comb. It prunes, traps and builds nests. He so admires the way that a bird can dance, with its fine little ankles and fine little feet. He awakens us to a sense of the bird's character. He has begun to sound a little like David Attenborough.

Black Ruskin hated the colour black, and it was perhaps for this reason that he had his mother's coffin painted blue. Furthermore, a brilliant blue was the colour of his own piercing eyes, and also the colour of the long neckcloths he favoured, lifelong. Oh, to have one's dear, departed, ever domineering mother forever at one's throat! (See **Mother**.)

Books and their Titles Very few of Ruskin's many, many books are in print. There are a few anthologies of selections from his voluminous writings, excerpted from books and lectures. His collected works, all 39 volumes of them (see **Cook and Wedderburn**), went out of print long ago. One of the reasons for this may be his capacity for dreaming up either yawningly dull or utterly incomprehensible titles. Who would wish to buy a book if the title gave you no indication whatsoever of the journey ahead? The difficulty with Ruskin is that even his books with declared aims – *The Stones of Venice*, for example (see **Venice**) – often drift away in other directions, so that what you begin by committing yourself to somehow transforms itself into something rather different as you read on and on. There are other problems too. Who reads art criticism for pleasure other than art critics, and an art criticism moreover that is not quite what it seems after a little while; a species of art criticism, for example, which slowly morphs into a treatise on 19th-century geology, as does Ruskin's *Modern Painters (see **Modern Painters**)*? He just cannot seem to stop himself going off the point. Those titles are something else altogether. Who would know what to expect if a book that purports to be an autobiography was called *Praeterita* (see **Praeterita**) or a book addressed to the working folk of Britain, *Fors Clavigera* (see **Fors Clavigera**)? Would all readers be required to understand Greek and Latin before they were ushered into the company of the Professor? It does seem so.

Book-Making (Childish) Ruskin's published books run into the hundreds. No one has written books more feverishly, and with more

exhaustingly relentless industry. And then re-written them again when they came to be re-published: he was forever revising his opinions, a nightmare for any bibliographer. Before becoming a book-man, he was a dedicated book-boy in his childhood, making his own from a very early age. These were often abstruse compilations of this and that, reflecting the fact that, young and old, Ruskin was never content to stick to a single topic when several could be weighed in the mind simultaneously. He was forever picking things up and then putting them down again. His parents thought it a good idea that he should earn his pocket money, and so they paid him for his different literary endeavours at variable rates: 'Homer' came in at a shilling a page; 'Composition' was paid at the rate of one penny for 20 lines; an article on 'Mineralogy' merited a single penny.

Brantwood In 1871 Ruskin, running away from the fame and the attention of the public figure that he had become in London, took a dramatic step in the direction of a life of seclusion. He bought a modest farmhouse with some land on the east side of Coniston Water in the Lake District for £1,500 from a minor poet and wood engraver called W.J. Linton. It was a small place – old, damp, decayed, rat-riddled and smoky-chimneyed, with five acres of rock and moor – as he described it to a friend, set against the drama of the abruptly rising fells at its back. Perhaps life there, he fondly dreamed, would be somewhat akin to the one lived by the poet William Wordsworth and his sister at Dove Cottage, which was also in the Lake District. It was not to be. He was joined there by his Scottish cousin, Joan Severn (see **Severn**), who became his housekeeper and, in time, his carer. Joan's view of the property was quite different from Ruskin's. Little by little, she both increased the house in size and aggrandised it. Her own family grew and grew too: she had five offspring of her own, each one requiring more and more space. In time, Brantwood became more a country house on a leisurely

scale than the modest dwelling that Ruskin had purchased. And even Ruskin's little dwelling at the front, facing the water then as now, had a turret and a grand dining room added on the side, with windows in Ruskin's favoured Venetian Gothic. A large studio was built into the fellside behind the house for the use of her husband, Arthur Severn, a landscape painter of outstanding mediocrity, whose works Ruskin himself had the tact to ignore. The house was a building site for the duration of his life. Ruskin died there in 1900, and was buried in the cemetery at Coniston, the village just across the water. Ruskin paid for everything without demur. The curator of the little Ruskin Museum in Coniston still holds strong opinions about the actions of the Severns. *He was their meal ticket*, she has commented. Unfortunately, life proved to be a less solitary affair than Ruskin had anticipated. Ruskin found it difficult to bid adieu to his fame. Letters arrived by the sackful, and he employed several secretaries to keep up with all the correspondence. He also found it difficult not to travel – until infirmity, mental and physical, eventually pinned him to the spot.

Brontë, Charlotte, on reading a work by Ruskin *I have lately been reading* Modern Painters, *and I have derived from the work much genuine pleasure and, I hope, some edification; at any rate it made me feel how ignorant I had previously been on the subject which it treats. Hitherto I have only had instinct to guide me in judging of art; I feel now as if I had been walking blindfold – this book seems to give me eyes. I do wish I had pictures within reach by which to test the new sense. Who can read these glowing descriptions of [J.M.W.] Turner's works without longing to see them? However eloquent and convincing the language in which another's opinion is placed before you, you still wish to judge for yourself. I like this author's style much; there is both energy and beauty in it: I like himself too, because he is such a hearty admirer. He does not give Turner half-measure of praise or veneration; he eulogizes, he reverences him (or rather his genius) with his whole soul. One can sympathize*

with that sort of devout, serious admiration (for he is no rhapsodist) one can respect it; and yet possibly many people would laugh at it.

Letter to W.S. Williams, 31 July 1848

Brougham, Double In 1875, Ruskin raised two fine and slender fingers to the ever widening, and ever more hatefully destructive, railway network – trains had been seen chuffing steadily along the other side of the valley above Coniston Water since 1859, directly within the line of sight from his study window – by behaving anachronistically. In that year he commissioned a luxury coach, a double brougham, from a coachbuilder called Tucker of Camberwell, at the outrageous cost of £190 (or £21,750 today), in order to make the journey north from London to the Lake District, travelling by coaching routes that were less and less used. Characteristically, he got involved in its design. *One great change I have made*, he wrote to his housekeeper Joan Severn, *is to have softly cushioned panels instead of glass . . . for people on the front seat to lean against. The two front glasses and door glasses will be enough for me.* The coach came complete with various hidden compartments, sliding windows, mud guards, padded seating, a retractable step, and a bath on the roof to accommodate any number of absolutely necessary books. When it swept into a posting inn in Sheffield in 1876, crowds of the poor of Sheffield gathered to look. An early instance of champagne socialism from a man who would never have dreamt of describing himself in such terms? Or just the same old rich poseur's excess?

Browning, Robert and Elizabeth Barrett Ruskin was very keen on poetry. He gushed forth many mediocre poems of his own, especially when young. His parents wrongly thought that he might become a poet to be remembered by posterity – his high point was when he won the Newdigate Prize for Poetry in 1839 when a student at Oxford, for a poem called 'Salsette and Elephanta'. It was only when he came to the

conclusion that his talent would never be the equal of Keats that he reluctantly conceded that being a great poet – and not merely another relatively able versifier – was not within his compass. Nevertheless, he was very knowledgeable about poetry and poets, both that of his contemporaries and the poetry of earlier times – Dante was a particular touchstone – and in his writings he often compared the different ways in which poetry and paintings work on us. Ruskin counted Robert and Elizabeth Barrett Browning amongst his many poet-friends, and he wrote letters to them that were both intimate and funny. Of the two, he judged Elizabeth Barrett to be the greater poet, calling her wildly popular verse-novel *Aurora Leigh* (read even by Queen Victoria), with ridiculous hyperbole, *the greatest poem in the English language; unsurpassed by anything but Shakespeare, not surpassed by Shakespeare's Sonnets – and therefore the greatest poem in the language.* He was less enthusiastic about Browning's poetry. It was too obscure. Browning retorted that if Ruskin genuinely preferred the clarity of prose, he should read tenancy agreements or wills.

Letter to Robert Browning, 27 November 1856,
quoted in E.T. Cook, *The Life of John Ruskin*, vol.1, p.461

Burne-Jones, Edward They had first met at Oxford, introduced by Dante Gabriel Rossetti (see **Rossetti**). Burne-Jones was overwhelmed by Ruskin and his fame. He asked Ruskin to contribute to a magazine he was co-editing with William Morris (see **Morris**) and others. Ruskin said yes. *I'm not Ted any longer, I'm not E.C.B. Jones now – I've dropped my personality,* Burne-Jones wrote in a letter after receiving Ruskin's note – *I'm a correspondent with RUSKIN, and my future title is 'The man who wrote to Ruskin and got an answer by return'. I can better draw my feelings than describe them, and better symbolise them than either.* Georgiana Burne-Jones printed this letter in her *Memorials of Edward Burne-Jones* (vol.1, p.127), with *a drawing of himself prostrate on the ground*

before an aureoled and nimbused presence intended for Ruskin. Ruskin regarded Edward Burne-Jones as one of his young protégés, and protégés require a great deal of instruction to set them on the right road. Somewhat later Ruskin, who had less appetite for reckless praise than his disciple, referred to some of Burne-Jones's early works as *nasty black and brown things.* Ruskin easily settled into moods of extreme exasperation. Why in heaven's name wouldn't these young upstarts do as they were told! *Jones is always doing things which need one to get into a state of Dantesque Visionariness before one can see them,* he bitterly complains to Charles Eliot Norton in a letter of 4 November 1860, *and I can't be troubled to get myself up, it tires me so.* In 1863 he paid for Burne-Jones and his wife Georgiana to visit Italy in his company so that the young man from Birmingham whose surname had once been nothing grander-sounding than Jones, could study, and be positively influenced by, the *right kind of art.* A new lightness, a new lyricism soon became evident in the work. By 1883, Ruskin included Burne-Jones in a lecture delivered at Oxford called 'The Mythic School in England'. To be mythic was evidently a move in the right direction.

Cameron, Julia Margaret, on not photographing Mr Ruskin *During the time that Mr Ruskin was with us Mrs Cameron, a very well known portrait photographer of those days was also with us on a visit and the two had frequent skirmishes about photography. I was lying on my couch in the drawing room one day when Mrs Cameron insisted on showing Mr Ruskin some of the wonderful heads of well-known people which she had taken. He got more and more impatient until they came to one of Sir John Herschel in which his hair all stood up like a halo of fireworks. Mr Ruskin banged to the portfolio, upon which Mrs Cameron thumped his poor frail back, exclaiming 'John Ruskin you are not worthy of photographs!' They then left the room. Mrs Cameron wore a red bonnet with strings & when she got very excited she pushed it back & it hung down her back by the strings.*

Apparently they went out but arrived back to luncheon arm in arm with the bonnet on & peace signed.

<div align="right">

Sarah Angelina Acland, 'Memories in my 81st Year',

Bodley Eng Misc d 214, fol.46.

</div>

Canaletto According to Ruskin, Venetian painting suffered a sudden death in 1594 (the year of the death of Tintoretto – see **Tintoretto**), almost two centuries before a painter called Canaletto painted *his* Venetian scenes for purchase by visually besotted aristocrats idling their way through the Grand Tour. Ruskin, never a man to mince his words, thought Canaletto's work utterly wretched, in fact beneath contempt. What exactly was wrong with it? He told us in the first volume of *Modern Painters (*see ***Modern Painters)***, which was published in 1843 when Ruskin, at just 24 years old, was already sounding much older, more experienced and more knowledgeable than his age might suggest. Ruskin called the Venice that Canaletto conjured into being a miserable, virtueless, heartless mechanism. The paintings themselves were servile and mindless imitations, vulgar and exaggerated, of nothing that could actually be seen by the human eye. So much for Canaletto. Had he read Ruskin's crushingly severe words, he might have felt sufficiently demoralised to take a long break in, say, London. In fact, that is exactly what he did.

Capitalism Were Marx and Ruskin singing from the same hymn sheet? Not exactly. They both shook their fists at capitalists and their exploitative ways. They both regarded the landowning gentry, who treated their workers with contempt, as swine. But Ruskin never suggested for a moment that a worker might change places with an aristocrat. Ruskin was a man who believed in hierarchies. He might wish to better the lot of the poor, but he had no intention of suggesting that every man might be equal in the sight of God. He was no believer in equality. He was no

believer that, at some future date, it would be correct for the workers of the world to come together and topple the likes of John Ruskin from his pedestal.

Caricature A caricature by Adriano Cecioni of a willow-thin, haughty Ruskin appeared in *Vanity Fair* on 17 February 1872 with the title: 'Men of the Day, No.40 – the Realisation of the Ideal'. It was not greatly loved by Ruskin. The text accompanying it read: *There is perhaps no harder fate in store for a man than to be irredeemably at variance with the spirit of the country and the times in which he lives; and it is Mr Ruskin's great misfortune to be an incurable poet and artist in a materialistic and money grubbing generation. He is so entirely out of harmony with all of modern life that surrounds him that he is by many regarded as an anachronism rather than as a man, and that his views are looked upon rather as vain protests than as serious opinions by those who have not bowed the knee to the modern Baal. He will be greatly remembered as one preaching in the wilderness the abandonment of the grosser things of life and the realisation of the Ideal . . . The English people have become meanly practical, and he is grandly unpractical; they have become essentially commonplace, and he is gloriously poetical; they believe in nothing more than cash; he believes in nothing less.* How accurate was the caricature? Charles Fortescue-Brickdale, who attended Ruskin's Oxford lectures in the 1870s, wrote this: *The* Vanity Fair *drawing, though, of course, a good deal exaggerated, gives a vivid and true idea of his general appearance at the date when his Slade professorship began.*

Carlyle, Thomas There was a powerful bond between Ruskin and Carlyle. Both men of Scots descent, they were kinsmen in various other ways too. Both were violently opinionated on social issues. What is to be done about the idling masses? thundered Carlyle, Ruskin and Lenin (in that order). Ruskin delighted that Carlyle felt, like he, so passionately

opposed to *the modern Liberal politico-economist of the [John] Stuart Mill school [who] is essentially of the style of a flat-fish – one eyeless side of him always in the mud, and one eye, on the side that has eyes, down in the corner of his mouth – not a desirable guide for man or beast.* There were also large differences between the two men. Carlyle had little interest in art, and was relieved and delighted when Ruskin's writing and passions turned social. Ruskin grew weary of Carlyle's cantankerousness, of his inability to see much beyond himself. On the other hand, *the book he makes bitterest moan over, Friedrich* [Carlyle's multi-volume history of Frederick the Great of Prussia], *bears the outer aspect of richly enjoyed gossip. What I chiefly regret and wonder at in him is the perception in all nature of nothing between the stars and his stomach, – his going, for instance into North Wales for two months, and noting absolutely no Cambrian thing or event, but only increase of Carlylian bile.* Physically, they differed much too. Ruskin was delicate of frame, Carlyle much less so. And yet, Ruskin wrote, *Carlyle is the only living writer who has spoken the absolute and perpetual truth about ourselves.* Carlyle also led Ruskin into the sorry Governor Eyre affair (see **Governor Eyre of Jamaica**), which did Ruskin's reputation no good whatsoever.

FC, letter 10, p.204, and *CEN*, vol.2, p.190, letter of 10 March 1883

Carpaccio, Vittore Later in life, Ruskin grew very fond of the paintings of Carpaccio, painter of narrative scenes of his native Venice. The freshness of Carpaccio's evocation of colourful, canal-side civic display in the 16th century transported the old man. *The architecture of Venice was in her glorious time; trim, dainty – red and white like the blossom of a carnation, – touched with gold like a peacock's plume, and frescoed, even to its chimney-pots, with fairest arabesques, – its inhabitants, and it together, one harmony of work and life – all of a piece.* He copied a cycle of paintings devoted to the subject of St Ursula, housed in the Accademia Gallery in Venice. The look of her reminded him of his beloved, now

dead Rose La Touche (see **La Touche**). *They have been very good to me in the Academy, and have taken down St Ursula and given her to me all to myself in a locked room and perfect light . . . I have a couple of hours tête-à-tête with St Ursula, very good for me . . . I strike work at two or a little after – go home, read letters – dine at three – Lie on sofa and read any vicious book I can find to amuse me – to prevent St Ursula having it all her own way.*

CEN, vol.2, p.140, letter of 5 October 1876

Carroll, Lewis They knew each other at Oxford, but they were never close. Ruskin and the Reverend Charles Lutwidge Dodgson (known to the wider world, a touch more informally, as Lewis Carroll) were members of the same college, Christ Church. Dr Liddell, the father of the original Alice (in Wonderland), was one of the two men who acted as Ruskin's sponsors when it was proposed that he, England's most celebrated and controversial art critic, be appointed the very first Slade Professor of Fine Art at Oxford. Ruskin got the job, and he became a sensation at it, packing auditoria to the rafters. Official transcripts of those lectures can be read in the *Library Edition* of Ruskin's works (see **Cook and Wedderburn**), but they feel bloodless because no one thought to record the casual, on-the-day, humorous asides, the dance steps, the jokes, the bird imitations. Carroll photographed Ruskin on more than one occasion, leaning back contemplatively in a leather armchair, appraising the middle distance. In short, not looking at Carroll. Did Ruskin ever much look at him? Or did he merely exist alongside a mathematician called Lutwidge Dodgson, and occasionally stoop to take advantage of the latter's evident talents for a relatively new-fangled invention that Ruskin came to rather like (and perhaps also a little distrust) called photography? *No, no, Rev. Dodgson, photography is definitely not an art form.* Did Ruskin ever say that to the man part-hidden beneath the black cloth? They exchanged letters, but Ruskin thought Dodgson's views about art were rather unremarkable. A brace of incompatibles

then, Dodgson a bit too puckish for the high-minded professor when he wasn't dancing for the students.

Childhood Ruskin's was not a childhood peopled by many companions of his own age. According to his late autobiography *Praeterita* (see **Praeterita**), he had few toys, and instead spent his time observing such things as the water cart out in the street and the intricate patterns in the carpet. The boy had nothing to love, he wrote. *I had no companions to quarrel with, neither; nobody to assist, and nobody to thank. Not a servant was ever allowed to do anything for me, but what it was their duty to do.* This was not quite true. He owned a good few toy soldiers, and enough toy bricks to conceive an entire architectural scheme. What is more, his cousin Mary Richardson lived at the house. According to Ruskin's first biographer, she was a spirited lass, four years his senior, who managed to hold her own. She even became a sister of sorts. *They learnt together, wrote their journals together, and shared alike with the scrupulous fairness which Mrs. Ruskin's sensible nature felt called on to show.* He was largely home-schooled by his doting and domineering parents (see **Father** and **Mother**), who saw great things in him. He could be wilful. *This will be cured by a good whipping*, his mother once wrote, *when he can understand what it is.* Unsurprisingly, he would forever be seeking their approval. *My parents were – in a sort – visible powers of nature to me, no more loved than the sun and the moon: only I should have been annoyed and puzzled if either of them had gone out (how much, now, when both are darkened!) – still less did I love God; not that I had any quarrel with Him, or fear of Him; but simply found what people told me was His service, disagreeable; and what people told me was His book, not entertaining.*

> *PRAE*, pt.1, ch.2, 'Herne Hill Almond Blossoms', section 50 (abridged);
> W.G. Collingwood, *The Life of John Ruskin*, p.26

Cigars The older he became, the more Ruskin fulminated against the evils of the civilisation in which he increasingly found himself to be a misunderstood and widely vilified stranger. Modern habits were both disgusting and destructive of the moral fibre of humanity, and few were worse than the current obsession with puffing on fat cigars. *Tobacco is the worst natural curse of modern civilisation*, he thundered in *Queen of the Air. It is not easy to estimate the demoralizing effect on the youth of Europe of cigars, in enabling them to pass their time happily in idleness.*

QA, footnote to p.116

Clouds Ruskin was forever trying to wrestle with clouds, marvelling at their impossibly airy coming-and-going-ness, their magical changeability, their fleetingly form-ful formlessness. He kept cloud diaries, cloud notebooks, made cloud paintings and drawings. He never stopped asking himself about the visual mystery of clouds. *How is a cloud outlined? Granted whatever you choose to ask, concerning its material, or its aspect, its loftiness and luminousness, – how of its limitation? What hews it into a heap, or spins it into a web? Cold is usually shapeless, I suppose, extending over large spaces equally, or with gradual diminution. You cannot have in the open air, angles, and wedges, and coils, and cliffs of cold. Yet the vapor stops suddenly, sharp and steep as a rock, or thrusts itself across the gates of heaven in likeness of a brazen bar; or braids itself in and out, and across and across, like a tissue of tapestry; or falls into ripples like sand; or into waving shreds and tongues, as fire. On what anvils and wheels is the vapor pointed, twisted, hammered, whirled, as the potter's clay? By what hands is the incense of the sea built up into domes of marble?*

MP, vol.5, pt.7, section 9, ch.1

Coach Travel Ruskin enjoyed few things more than travelling by coach, and he did so from a very early age, in the company of his parents. They travelled through France, Germany, Switzerland, Italy – and Great

Britain too. Coach travel enabled him to move at a relatively steady pace, which meant that he could indulge his insatiable appetite for the keen observation of mountains, trees, rocks, rivers, flowers. The coach could be made to stop at whim, giving him an opportunity to sketch a rearing escarpment or a river in full spate. There was also something rather eye-catchingly flamboyant about coach travel, and Ruskin always rather wanted to be noticed as a grandee perpetually on the move. In old age, he looked back to the virtues of *the travelling carriage in old times*. In fact, what he was almost certainly remembering was his own experience of the pleasures of coach travel, which would have included observing the habits of French horses . . . *The French horses, and more or less all those on all the great lines of European travelling, were properly stout trotting cart-horses, well up to their work and over it; untrimmed, long-tailed, good-humouredly licentious, whinnying and frolicking with each other when they had a chance; sagaciously steady to their work; obedient to the voice mostly, to the rein only for mere explicitness; never touched by the whip, which was used merely to express the driver's exultation in himself and them, – signal obstructive vehicles in front out of the way, and advise all the inhabitants of the villages and towns traversed on the day's journey, that persons of distinction were honouring them by their transitory presence.*

> *PRAE*, pt.1, ch.6, 'Schaffhausen and Milan', section 125

Cobwebs When Ruskin was at work in Venice, nothing would deflect him from the all-important and all-consuming task of recording details of all those ancient buildings he loved so much. In fact, his wife Effie (see **Gray**) often saw little of him at all. He was always too busy taking notes, sketching, measuring, shinning up ladders, or poking into mouldering tombs. She catches a memorable glimpse of him in this letter back home to her mother, written from the Hotel Daniele on 24 February 1850: *John excites the liveliest astonishment to all and sundry in Venice and I do not think they have made up their minds yet whether he is very mad*

or very wise. Nothing interrupts him and whether the Square is crowded or empty he is either seen with a black cloth over his head taking Daguerrotypes or climbing about the capitals covered with dust, or else with cobwebs as if he had just arrived from taking a voyage with the old woman on her broomstick.

Collecting Visitors The Ruskins, father and son, were great collectors of paintings, and John Ruskin took great pleasure in showing them off to guests. The account books of John James Ruskin (see **Father**) enable us to imagine what those guests might have been looking at in the dining and drawing rooms at the Ruskin family home in Herne Hill, south of London. In addition to family portraits, there would have been works by Samuel Prout, William Holman Hunt, David Roberts, Copley Fielding, G.F. Watts and George and Thomas Richmond. The pride of the collection in the drawing room would have been its 15 paintings by Turner, including *The Slave Ship*. Other Turners were in Mr and Mrs Ruskin's rooms. Ruskin Junior's collection of minerals were kept in a room on the second floor of the house, next to his bedroom. Who would have been looking? *Dinner was usually at six, thus allowing guests a view over the field and the Norwood hills in the evening light.* Dinner guests might have included any combination of the following: J.M.W. Turner (see **Turner**), G.F. Watts, Millais (see **Millais**), Holman Hunt, Dante Gabriel Rossetti (see **Rossetti**), William Morris (see **Morris**), Coventry Patmore, Edward Burne-Jones (see **Burne-Jones**), the Brownings (see **Browning**), Henry James, Charles Kingsley, Tennyson (see **Tennyson**). Testy Thomas Carlyle (see **Carlyle**) might have ridden over from Cheyne Walk on his horse Fritz.

James S. Dearden, *John Ruskin's Camberwell*, p.16

Communism *I am a Communist of the old school*, Ruskin declared in one of his letters to the working men of Britain in *Fors Clavigera* (see *Fors Clavigera*). This is a very different species of Communism from the one

associated with the writings of Marx and Engels. There is no mention of the violent social ructions associated with the rising up of the proletariat, or of the supplanting of one ruling class by another. Ruskin would never have countenanced such a thing. Ruskin's Communism was about the theft of creativity, Marx's about the theft of labour. Under Ruskin's Communism, people worked harmoniously at simple, common tasks; his Communism drew attention to the importance of the common ownership of publicly valued things such as civic buildings, foresaw the common ownership of knowledge (including scientific knowledge) and the creation of a treasure of fine things (a storehouse of public wealth rather than the shaming legacy of public debt) held in common for public betterment (such as would happen in his museum in Sheffield – see **St George's Museum**). His Communism pleaded for the adornment of public buildings on their exteriors – frescoes and fine sculptures, for example, so that everyone could enjoy the sight of what had been achieved by great artists – as had been the case in his beloved Venice (see **Venice**). His impassioned outpourings on this subject were prompted by the mayhem that had been unleashed by the Paris Commune in the spring of 1871. To his horror, the Louvre had been set to the torch. Why had he, Ruskin, not been consulted, he asks his readers, before the Louvre was burnt down? Do not great art collections belong to all of us?

Conman A conman, trickster, gossip and tall-tale spinner called Charles Augustus Howell became Ruskin's secretary after the death of his father in 1864, inveigling himself into Ruskin's circle through his friendship with the Pre-Raphaelites (see **Pre-Raphaelites**). He became his runner, go-between, errand boy. He also pocketed some of Ruskin's money. Ruskin trusted him because he was the offspring of a man with connections to the Portuguese wine trade. Long after Ruskin had dismissed him, Howell published a series of madcap 'Letters of John Ruskin to His Secretary', telling various compromising tales about Ruskin's

reckless philanthropy, and what various odd gestures of generosity might tell the world about his mental health: Ruskin was going to employ a shop boy as an artist, commission the old and ailing George Cruikshank to illustrate a book of fairy stories, and was perhaps even the anonymous donor who had bought a canary at the Crystal Palace Bird Show (February 1866) in order to do its owner some good. Another of his tricks had some literary value in the longer term. In 1869 he exhumed a manuscript of Dante Gabriel Rossetti's poems from his wife's grave. Ruskin's mother saw through him. One evening she burst out at the dinner table: *How can you two sit there and listen to such a pack of lies?*

Constable, John Ruskin could blow hot and cold about the so-called English School of painting and portraiture of the late eighteenth and early nineteenth centuries. He dismissed Constable with a comprehensive, contemptuous sweep of the hand; the man's mind was simple and earnest enough, but he was essentially unteachable. He lacked the necessary veneration in his approach to nature. His early education was at fault too. He had been taught the *morbid* habit of favouring subjects of a low order. *I have never seen any work of his in which there were any signs of his being able to draw, and hence even the most necessary details are painted by him inefficiently. His works are also eminently wanting both in rest and refinement.* Even the weather in which Constable opted to work was ill-chosen, *for the showery weather in which the artist delights, misses alike the majesty of storm and the loveliness of calm weather; it is great-coat weather and nothing more. There is strange want of depth in the mind which has no pleasure in sun-beams but when piercing painfully through clouds, nor in foliage but when shaken by the wind, nor in light itself but when flickering, glistening, restless and feeble.* For all that, there remained a handful of reasons for not dismissing him entirely: originality, honesty, freedom from affectation, a certain manliness of manner, frequent displays of success in the use of cool colour. And the man did show some degree of affection

for the English scenery of his native Suffolk. Not entirely beneath contempt then. Gainsborough, on the other hand, was praised to the skies: the greatest colourist since Rubens. That was some claim!

MP, vol.1, pt.2, section 1, ch.7

Cook and Wedderburn Messrs Cook and Wedderburn were the joint editors of the 39-volume *Library Edition of the Works of John Ruskin* that began to be published in 1903, three years after his death. The last volume appeared in 1912. It sold badly. Its publication did the opposite of cementing his reputation: it precipitated its decline. What might have been his monument proved to be his tombstone. The fat, squat volumes, bound in cloth the colour of a ripe plum, scrupulously edited and annotated, a *tour de force* of scholarship, contain about 80 per cent of what he published during his lifetime, and relatively few of his thousands of letters. A certain skewing also took place, alas. The editors, both devoted Ruskinians, wanted to burnish Ruskin's reputation by presenting him not as the High Tory, which at heart he had always been, but as something of a liberal. A bit of deft cleaning up was called for. There are unforgivable omissions from its commentary upon his life. Ruskin and Oscar Wilde (see **Wilde**) had been close friends from 1875 to 1885. They dined together, and went to the theatre and pantomime almost arm in arm. Wilde gets not a single mention. The terrible taint of Wilde was rubbed from the historical record.

Copyists Ruskin was a great believer in commissioning replicas of works of art, whether they be paintings, sculptures, or details of buildings at risk of demolition. There was nothing to be despised about a good copy. So much great architecture was under threat. How otherwise would we have any idea of what priceless things were at risk of being lost forever? He himself made copies (often at great expense to his father), and he employed numerous others to copy on his behalf. Many of these

copies were put on display at his museum in Sheffield (see **St George's Museum**). He often pampered and petted his copyists, fretted over their welfare, played the part of nanny to near perfection. One of them, Frank Randal, was in Amiens recovering from a bout of toothache when Ruskin sent him this solicitous note. *Take care not to overwork yourself, take vigorous exercises every day, and always an hour's careful reading of any book, at breakfast time, (or before it, on wet days) so as to get a foundation of thought for the day. Get as early to bed as you can sleep; and study diet, so far as you find it affects you, till you know thoroughly what is good for you . . . without clouding the brain.*

> Louise Pullen, *Genius and Hell's Broth: A Tale of Two Guild Artists – Frank Randal and William Hackstoun*, p.9

Creswick, Benjamin The young Benjamin Creswick of Bell Hagg Road, Sheffield, was under sentence of slow death when he visited Ruskin's new St George's Museum, which opened in the hills just outside the city in 1875 (see **St George's Museum**). His doctor had told him so. Creswick, who worked as a knife grinder, had the beginnings of a serious lung complaint, and the life expectancy of a worker in that trade, with dust blowing back into the lungs as the mill wheel turned and turned, was horrifyingly low. According to Karl Marx's friend and collaborator Friedrich Engels, writer of *The Condition of the Working Class in England* (1845), a fork grinder could expect to live to the age of about 28. Creswick was determined to become a sculptor, and he visited the museum repeatedly – it was within walking distance of his house. Eventually, its curator, Ruskin's friend Henry Swan, brought the lad to Ruskin's attention and Ruskin, with characteristically impulsive generosity, invited him up to his home in the Lake District to learn his trade and make a bust of Ruskin. That fine bust was eventually given by Ruskin to Prince Leopold, Queen Victoria's haemophiliac son. Ruskin supported Creswick and his family in the Lake District for four years,

and the young sculptor's talents bore fruit. He moved to London. He made stone friezes for shop fronts (he was particularly adept at working in terracotta) – Heath the Hatters on Oxford Street, for example – and eventually became a professor of fine arts in Birmingham, promoting the ideals of the Arts & Crafts movement.

Cyanometer In 1835 Ruskin was travelling once again with his parents on the Continent, and, as ever, he was furiously busy at a huge variety of tasks. He was keeping one eye cocked to the sky in order to advance his knowledge of meteorology; he was studying geology with the aid of a book by an eminent late 18th-century geologist called Horace Bénédict de Saussure; he was sketching in a rather flecky way in the manner of Samuel Prout; he was keeping a descriptive journal of the tour in prose, and another in verse, because he and his parents still believed that he had a future as a great poet. And he was also studying the hue of the clouds and the blueness of the Rhine with the aid of an ingenious invention called a cyanometer. This device, self-made out of cardboard and paper, enabled him to measure the depth of tone of any particular blue, be it that of sky or water.

Cycling *I not only object, but am quite prepared to spend all my best 'bad language' in reprobation of the bi-, tri-, and 4- 5- 6 or 7 cycles, and every other contrivance or invention for superseding human feet on God's ground. To walk, to run, to leap, and to dance are the virtues of the human body, and neither to stride on stilts, wriggle on wheels, or dangle on ropes, and nothing in the training of the human mind with the body will ever supersede the appointed God's way of slow walking and hard working.* NB: Two of Ruskin's closest help-mates – his publisher George Allen, and the curator of his museum in Sheffield, Henry Swan (see **Swan**) – were keen cyclists.

Words ascribed to John Ruskin, *Tit-Bits*, 31 March 1888

Daguerreotypes Ruskin quickly came to appreciate that the making of daguerreotypes (the first commercial photographic process) would enable him to capture the qualities and the textures of buildings in the most minute detail, something that a drawing or a painting might struggle to equal. A daguerreotype could, for example, flatten a surface, thus making it easier to read and describe. By 1845 he had bought his own machine. His servant Hobbes was pressed into service to operate it. Later in life, his enthusiasm for photography waned somewhat. Could photography really be regarded as an important art form in its own right? Surely it would always be an aid to memory or a document from which an engraving might be worked up . . . Drawings and paintings, by comparison, were powered into being by the emotional engagement of the artist. To make a photograph was a coolly clinical affair by comparison with what the miraculous combination of hand and eye could achieve.

Daily Routine, Venice *I rise at half past six: am dressed by seven – take a little bit of bread; and read till nine – then we have breakfast punctually: very orderly served – a little marmalade with a silver leafage spoon on a coloured tile at one corner of the table – butter very fresh – in ice – grapes and figs – which I never touch; on one side – peaches on the other – also for ornament chiefly – (I never take them) – a little hot dish, which the cook is bound to furnish every morning – a roast beccafico – or other tiny kickshaw – before Effie, white bread and coffee: Then I read Pope or play myself till 10 – when we have prayers: and Effie reads to me and I draw till eleven: then I write till one when we have lunch: then I go out, and sketch or take notes till three – then row for an hour and half – come in and dress for dinner at 5, play myself till seven – sometimes out on the water in an idle way: tea at seven – write or draw till nine – and get ready for bed.*

Letter to his parents from Venice, 8 February 1852

Darwin and Darwinism You could call it a clash of two Titans of the Victorian age – except that it never came to that because Ruskin never openly engaged with Charles Darwin. Were they friends? No, at best they were acquaintances (Darwin was a dinner guest at Brantwood – see **Brantwood**). Ruskin read his works, but only in part. He attacked him side-long, by jest or silly joke. He could be rude about Darwin, even brutally dismissive – but never to his face. Did fear of the consequences of Darwin's ideas contribute to Ruskin's indirection? He tended to make marks in the books that he read, and to quote from them or, at worst, refer to them. His copy of *On The Origin of Species* is unmarked, and he never quoted from it. *The Descent of Man* (or, to give it its full and perhaps, for Ruskin, more disgusting title, *The Descent of Man, and Selection in Relation to Sex*), on the other hand, had a profound effect upon him and his sense of well-being, his optimism. Its pessimism caused great cracks to open up in Ruskin's world-view. It may even have helped to drive him mad. Its brutally sceptical message, for Ruskin, represented the death of hope. If we exist merely to reproduce, what point is there in living? Ruskin could never quite come to terms with Darwin's godlessness. The message was too stark for him, too baleful. It meant the dawn of joylessness.

Death Ruskin's death in 1900 – and Queen Victoria's in the following year – were events of national importance. Arts & Crafts architect Henry Wilson caught the mood at a London club when the news broke: *There came a sudden clamour outside, the door burst open and another well known artist rushed in dancing and frantically waving an evening paper. 'Ruskin's dead! Ruskin's dead!' he cried, before sinking into a chair. 'Thank God, Ruskin's dead! Give me a cigarette'.* In spite of the fact that Ruskin had spent the last decade of his life saying almost nothing, and in a state of seclusion and near inactivity at his home in the Lake District, his death marked the end of something profound. The Sage of Coniston

was dead. Perhaps the very idea of the Victorian sage was dead too. Did Ruskin's passing mark the collapse of paternalistic certitudes? (See **Reputation**.)

Lionel Lambourne, *Victorian Painting*, p.487

Deucalion Ruskin's later books about the natural world were marvellously wayward and odd and homely. The subject of *Deucalion* (1879) is mineralogy. Who, before Ruskin, would have recommended the use of bread dough and biscuits as a means of better understanding the lateral compression of strata? *This work of mine*, he declared, full of reckless optimism and self-praise (combined with a deft sideswipe at his enemies), *may stand out like a quartz dyke as the sandy speculations of modern gossiping geologists get washed away.*

Proserpina, vol.2, p.22

Dickens, Charles Ruskin read Dickens with enthusiasm, though he did not know the man himself. He wholeheartedly approved of the social criticism levelled at the bullying Mr Gradgrind in *Hard Times* (1854). Oddly, the novelist is likened to a small, cherubic-breasted bird with odd nocturnal habits in Ruskin's small, late book *Love's Meinie*, which is a description of some of the birds of Britain and Greece. *The robin is the Charles Dickens of birds*, Ruskin writes, rather hopping fancifully. Why so? Because he travels in the night (Dickens was a solitary nocturnal rambler), and in the company of no one but himself. All the more surprising then that he wrote of Dickens to his American friend Charles Eliot Norton rather harshly at the time of his death. *The literary loss is infinite – the political one I care less for than you do. Dickens was a pure modernist – a leader of the steam-whistle party* par excellence *– and he had no understanding of any power of antiquity except a sort of jackdaw sentiment for cathedral towers. He knew nothing of nobler power of superstition – was essentially a stage-manager, and used everything for effect on*

the pit. His Christmas meant mistletoe and pudding – neither resurrection from the dead, nor rising of new stars, not teaching of wise men, nor shepherds. His hero is essentially the ironmaster; in spite of Hard Times, *he has advanced by his influence every principle that makes them harder – the love of excitement, in all classes, and the fury of business competition, and the distrust both of nobility and clergy which, wide enough and fatal enough, and too justly founded, needed no apostle to the mob, but a grave teacher of priests and nobles themselves, for whom Dickens had essentially no word.* Was Ruskin himself that grave teacher of priests? For all the criticism, he found the novels enthralling to read, and would often quote from them. Sometimes you just never knew in which direction Ruskin would jump. Or skip. Or hop.

CEN, vol.2, pp 4–6, letter of 19 June 1870

Dogs Ruskin had a particular fondness for dogs. The partial disfigurement of his lower lip, noted by many of his close critics, is evidence of that passion. A family dog called Lion leapt at him one day. The scar remained. His very first portrait – done by James Northcote when Ruskin was three-and-a-half years old – shows him in the company of a brainless, harum-skarum, hither-and-thither-running, floppy-eared King Charles spaniel – the breed was a particular favourite of his. John is running too, just beside him, in his pretty girl's frock. Did he perhaps enjoy the name's association with royalty, the slight social elevation of it all? The dog in that portrait, whose name we do not know, was the first of many. The second, that dangerous Lion, was a hefty black Newfoundland, and it was bought as a guard dog when the Ruskins moved to their new house in Herne Hill, south of London. A dog called Gypsy arrived when John was ten, and Dash (another King Charles) joined him a year later. Bramble, Wisie and others came after, none of them quite as disrespectful of Ruskin's reputation as Lion. Grip, a pet rook, did no such thing, fortunately (see **Animals**).

Doge's Palace To Ruskin, the oh-so-delicate, salmon-pink wonder of the Doge's Palace in Venice was the architectural acme of the western world, and he lavished thousands of words of praise on it in *The Stones of Venice* (see **Venice**). Nothing was ever too pernickety-small for Ruskin's attentions. He marvelled over the sheer complexity of its historical accretions, Byzantine, Gothic and Renaissance. He clambered and nosed around everywhere. He especially admired the sculptures that wrapped around the capitals at the building's corners, the idiosyncratically different ways in which they were made to fit in by the ingenuity of their makers. Amongst his many favourites were the figures of Adam and Eve at the south-west corner, what he describes as the *Fig-tree angle*. The fig tree's limbs and foliage rise up ingeniously to hide their nakedness. That was the beauty of the spirit of Gothic: freehand making and shaping and carving was always so adaptable and consequently so pleasingly unpredictable. We can almost feel him squeezing himself up against it in order to miss absolutely nothing. *Nothing can be more masterly or superb than the sweep of this foliage on the Fig-tree angle; the broad leaves lapping round the budding fruit, and sheltering from sight, beneath their shadows, birds of the most graceful form and delicate plumage. The branches are, however, so strong, and the masses of stone hewn into leafage so large that, notwithstanding the depth of the undercutting, the work remains nearly uninjured; not so at the Vine angle, where the natural delicacy of the vine-leaf and tendril having tempted the sculptor to greater effort, he has passed the proper limits of his art, and cut the upper stems so delicately that half of them have been broken away by the casualties to which the situation of the sculpture necessarily exposes it.* Oh dear. Ruskin always possessed a very keen eye for those who fell short.

Ruskin in Venice, ed. Arnold Whittick, p.73

Drawing Drawing was at the heart of the great, lifelong Ruskin project of self-advancement and self-improvement. It was almost a form

of prayer. Everyone must learn to draw, whether they be lisping babe, aspiring artist or the local baker. To draw was to observe, to love and to cherish, to tell the truth. The more closely one drew, the more one observed, and the more one observed, the greater one's capacity for praise of the marvels of the universe. What to draw? Organic forms, their shapes, their textures, their marvellous unpredictabilities. From drawing would come understanding and appreciation, and a greater capacity to feel, thus bringing together matters of the heart and things of the mind. He recommended especially the drawing of stones. Who could have guessed at their colours, their textures, their shapeliness? *If you can draw that stone*, he wrote in *The Elements of Drawing*, *you can draw anything.*

Dutch Painting Ruskin's judgements were often skewed by two things: profound ignorance undeclared, or a fiercely judgemental moralising learnt at his overbearing mother's knee (see **Mother**). His views of Dutch painting of the 17th century were often foolish in the extreme. He could not bear the 'low-life' scenes of David Teniers the Younger. How awful to see how they cavorted in those inns with unruly dogs, slopping their steins of beer all over the place! His opinion of Rembrandt feels ignorant and ungenerous. His view of Dutch landscape art is pompous, sneering and spoken from a very lofty height for a man of 24. Just occasionally, he sprinkles a crumb or two of praise. *Among the professed landscapists of the Dutch school, we find much dexterous imitation of certain kinds of nature, remarkable usually for its persevering rejection of whatever is great, valuable, or affecting in the object studied. Where, however, they show real desire to paint what they saw as far as they saw it, there is of course much in them that is instructive . . . But the object of the great body of them is merely to display manual dexterities of one kind or another, and their effect on the public mind is so totally for evil, that though I do not deny the advantage an artist of real judgement may derive from the study of some of them,*

I conceive the best patronage that any monarch could possibly bestow upon the arts, would be to collect the whole body of them into a grand gallery and burn it to the ground. Fortunately for Vermeer, he was still completely unknown at this point, and therefore spared an ignorant, high-handed mauling.

MP, vol.1, pt.2, section 1, ch.7

Education Ruskin was a great believer in the positive influence of education upon children. Unsurprisingly, the regime he proposed was a taxing one. *Every child in a civilised country,* he wrote, *should be taught the first principles of natural history, physiology, and medicine; also to sing perfectly, and to draw any definite form accurately, to any scale.* A child should spend no more than three hours a day at school or perhaps less (it is often just as useful to give parents help at home). Fortunately for the future pupils, Ruskin could also have a bit of fun at the expense of his own pedagogical self. *If ever my St George's schools come to any perfection, they shall have every one a jackdaw to give the children their first lessons in arithmetic. I'm sure he could do it perfectly. 'Now, Jack, take two from four, and show them how many are left.' 'Now, Jack, if you take the teaspoon out of this saucer, and put it into that, and then if you take two teaspoons out of two saucers, and put them into this, and then if you take one teaspoon out of this, and put in into that, how many spoons are in this, and how many in that?' – and so on.* As for adults, *peasants* need not bother their heads over algebra, Greek or Latin, but it would be useful if they were to learn to organise their thoughts clearly, speak their own language intelligibly, know the difference between right and wrong, be taught to curb their own passions, *and receive such pleasures of ear or sight as life may render accessible.* Unlike a child, a *peasant* need not be taught to draw, *but certainly I would teach him to see; without learning a single term of botany, he should know accurately the habits and uses of every leaf and flower in his fields; and unencumbered by any theories of moral or political philosophy, he should help his neighbour and disdain a bribe.* Ruskin was also keen to

encourage the adoption of a national costume. *It is the peculiar virtue of a national costume that it fosters and gratifies the wish to look well, without inducing the desire to look better than one's neighbours – or the hope, peculiarly English, of being mistaken for a person in a higher position of life. A costume* may *indeed become coquettish, but rarely indecent or vulgar; and though a French bonne or Swiss farm girl may dress so as sufficiently to mortify her equals, neither of them ever desires or expects to be mistaken for her mistress.*

HI, p.102, and *MP*, vol.5, pt.9, ch.11

Eliot, George, semi-seduced by Ruskin's words *I don't know whether you look out for Ruskin's books whenever they appear. His little book on the Political Economy of Art contains some magnificent passages, mixed up with stupendous specimens of arrogant absurdity on some economical points. But I venerate him as one of the great teachers of the day. The grand doctrines of truth and sincerity in art, and the nobleness and solemnity of our human life, which he teaches with the inspiration of a Hebrew prophet, must be stirring up young minds in a promising way.*

George Eliot, letter to Miss Sara Hennell, 17 January 1858

Enamel Badge for Ruskinians A loose grouping of Ruskin enthusiasts exchange information about all matters Ruskinian through an organisation called Ruskin To-Day. It has its own website: ruskinto-day. org. In 2000 an enamel lapel badge was created so that Ruskinians could recognise each other, and then clasp hands if need be, when on the concourse at St Pancras Station or when footling about in the back row of the stalls at the Sydney Opera House. Or perhaps they could wear it when walking alone on the fells some rain-swept afternoon, before bellowing out into the upper air some of Ruskin's most beloved lines: ALL GREAT ART IS PRAISE; THERE IS NO WEALTH BUT LIFE. The badge and its logo were designed to mark the Ruskin Centenary (of

his death) in 2000. The motif is based on Ruskin's own adaptation of the rose on the dress of Venus in Botticelli's *Birth of Venus*. The badge costs £4.99. The organisation itself has no constitution, no bank account, no official membership, and anyone who wishes can wear the badge. What about it then?

English Constitution, The *I'm just putting the notes together for my last of twelve lectures. Here's a nicish little bit just concocted – I rather like it – I hope it'll make you laugh: – ENGLISH CONSTITUTION 'The rottenest mixture of Simony, bribery, sneaking tyranny, shameless cowardice, and accomplished lying, that ever the Devil chewed small to spit into God's Paradise.' I must write it fair, to be sure it's given without a slip of the tongue. They say my lectures have made rather an impression this term.*

Letter to Thomas Carlyle, 1875

Equality Ruskin did not believe in equality. He believed that every man or woman was born at a particular social level, and that it would be pernicious, dangerous and socially disruptive to interfere with what God had ordained. This did not mean that he lacked compassion for the lot of the poor, tubercular lamplighter of Whitechapel, desperately trying to scratch together a meagre living – he wept over newspaper cuttings. He had much compassion for the disadvantaged. He wished to improve their lot. He wanted them not to be overworked, and for their work to be satisfying, if not creative. Yet he also feared that one of the consequences of the poor acquiring more money – oh, filthy money, that *chronic abstraction from other people's earnings*! – might be the winging in of some vainglorious wish to better themselves socially, and for them to become the equal of their betters. This should not be tolerated. That said, Ruskin was more at ease in the company of those he would have regarded as his social inferiors.

Essential Books Ruskin was keen to create a library of essential books for the education of the working man. It was a strenuous and demanding list, strong on piety and the classics, which would include the following: the *Books of Moses*, the *Psalms of David* and the *Revelation of St John*. Ruskin would himself translate the works of Hesiod and Xenophon from the original Greek into English prose. From the Latin, there would be the first two *Georgics* and the sixth book of the *Aeneid* by Virgil, in Gawain Douglas's 16th-century translation. Dante's *Divine Comedy* would be included – perhaps in the original? Chaucer would be there, excluding *The Canterbury Tales* (too much bad behaviour?), but certainly including *The Romance of the Rose*. Jeremias Gotthelf's *Ulric, The Farm Servant*'s (in the French version) surprising presence on the list would remind Ruskin that this was the very book his own father used to read to him on their early tours of Switzerland. And, oh yes, there would also be an early English history by an Oxford friend. Other titles added later included Sir Philip Sidney's *Psalter*, and Ruskin's own biography of Sir Herbert Edwardes, under the title of *A Knight's Faith*.

Etymology Ruskin was very keen on digging deep into the roots of words, letting his ever-patient (we hope) readers know exactly what the different component parts of any words had actually meant in their original languages. He was also quite keen on coining new words (see **Illth**). Unfortunately, his etymological delvings could be profoundly unhelpful, because new words never quite mean what the parts they were made from amount to. How could they if they are new words altogether? They turn into something else. In fact, it is often terribly misleading to suggest that a word means exactly what the bits out of which it is composed mean when they are all bolted together. He also tended to construct baffling new words – and even entire titles for books – whose meanings look, at first sight, unfathomable. One such book is *Fors Clavigera* (see

Fors Clavigera). Ruskin is aware that the meaning of the title of the book will be wholly beyond the grasp of the working men of England to whom it is addressed, because he spends three pages of one of the letters (perversely, not the first, which would have been most helpful of all, but the second) taking the title to bits, and holding it up to the light of public scrutiny. So what does it mean? Here is a small part of his explanation. Why is it in Latin and not English? He asks his reader first. Because *the Romans did more, and said less, than any other nation that ever lived; and their language is the most heroic ever spoken by man.* Is that enough of a justification? Ruskin thinks so. *Fors,* he then tells us, *is the best part of three good English words: force, fortitude and fortune. Clava means a club, Clavis a key, and Clavus a nail or a rudder. Gero means to carry. So Clavigera may mean, therefore, either Club-bearer, Key-bearer or Nail-bearer. Each of these three possible meanings of Clavigera corresponds to one of the three meanings of Fors. Fors, the Club-bearer, means the strength of Hercules, or of Deed. Fors, the Key-bearer, means the strength of Ulysses, or of Patience. Fors, the Nail-bearer, means the strength of Lycurgus, or of Law.* How to summarise all this in a few words written in plain man's English? Would *fate which hits the nail on the head* do the trick? Or would you prefer something slightly wordier?

Eyes It is not altogether surprising that a man who lived to read and to write should be obsessed with his eyes. He fretted over the possible cause of these anxieties. Over-work? Too many eggs for breakfast? At Oxford he was nicknamed Giglamps because of the tinted glasses he chose to wear. He writes in his diaries of floating sparks, spots, motes, his fear that his sight might not last until the work he has to do was complete. Even at the tender age of 21 he was committing prayerful hopes such as these to his diary: *I thank God for giving me a few more such hours and scenes, while my eyes are still so far perfect. If it gets weaker, I think I shall stay in Italy or Switzerland. What have I to go home for?* For all his fears,

his eyes survived very well, and in 1886 he was telling his diary, with some confidence, *that I see everything far and near down to the blue lines on this paper and up to the snow lines on the* [Coniston] *Old Man – as few men of my age.*

<div align="right">Diary, 22 October 1840 and 30 May 1886</div>

Father John Ruskin's father, John James Ruskin – unlike his feckless father before him – was a shrewd, successful and hard-working businessman of Scots descent who, in common with his wife (see **Mother**), never ceased to propel the destiny of his only son in the direction he thought it should be going. He was also a collector of paintings, including the works of J.M.W. Turner (see **Collecting Visitors**). In 1814, John James set up a business importing sherry with Pedro Domecq and Henry Telford. Ruskin made it prosper – often single-handedly. He travelled widely soliciting custom, often in the company of his wife and young son, thus guaranteeing that Ruskin Junior would soon command a good knowledge of the geography of the British Isles. At the age of eight, John Ruskin produced a fine, meticulous map of Scotland in brown ink and watercolour. He had visited the country three times before he reached the age of ten, and had fallen in love with both its mountainous landscape and the novels of Sir Walter Scott. What were the father's faults? He could never bear to be bested at anything. His would be the final word – until his wife laid her trump card down on top of his. *The chief fault in my father's mind*, his son hazarded to write decades after his father's death, *was his dislike of being excelled. He knew his own power – felt that he had not nerve to use or display it, in full measure; but all the more, could not bear, in his own sphere, any approach to equality. He chose his clerks first for trustworthiness, secondly for –* in*capacity. I am not sure that he would have sent away a clever one, if he had chanced upon such a person; but he assuredly did not look for mercantile genius in them, but rather for subordinates who would be subordinate for ever.* His look in old

age was said to be that of *a dry antique little man in a lean frockcoat of olde-world shape*. Like father, like son.

<div align="right">

PRAE, pt.1, ch.10, 'Quem Tu, Melpomene', section 197;

D.Hudson, *Man of Two Worlds*, p.166

</div>

Fish (and Liberty) *You hear every day greater numbers of foolish people speaking about liberty, as if it were such an honourable thing: so far from being that, it is, on the whole, and in the broadest sense, dishonourable, and an attribute of the lower creatures. No human being, however great or powerful, was ever so free as a fish. There is always something that he must, or must not do; while the fish may do whatever he likes. All the kingdoms of the world put together are not half so large as the sea, and all the railroads and wheels that ever were, or will be, invented are not so easy as fins. You will find, on fairly thinking of it, that it is his Restraint which is honourable to man, not his Liberty.*

<div align="right">

LEJR, vol.16, p.407

</div>

Fors Clavigera *Fors Clavigera* is quite unlike all Ruskin's other works, both in the kind of book that it is, and in the way in which it was distributed, privately, by his friend and former pupil George Allen, avoiding bookshops altogether. It was a series of long letters – the first is dated 1 January 1871 – addressed directly to the workmen and labourers of Great Britain, in which he pours forth all his hopes, fears and anxieties about the state of the country in which he finds himself. It switches from subject to subject, seemingly without premeditation. This is Ruskin writing on the hoof, breathlessly responding to the day's pressing events, the day's weather, the day's news, the day's political turns-and-turns-about. If it were written now, it would be presented as a blog, with many bizarre hyperlinks. It is intimate in its address. Why then did he choose to give it such a bizarrely unapproachable title in Latin? Who has ever understood that title? How did it come about? (See **Etymology**.) For all these

traps set in the way of the unwary reader, this is Ruskin the public man at his most plain-speaking and forthright. *I neither wish to please nor to displease you; but to provoke you to think; to lead you to think accurately; and help you to form, perhaps, some different opinions from those you have now.*

FC, Letter 6, p.106

Fustian One of the most serious charges we could level against Ruskin is that he is a dealer in fustian, as irredeemably remote from us as those portraits of him in sepia seem to suggest, receding further back in time even as we stare and stare in near incredulity. Much of this is true. He is not one of us in the way that other great Victorians seem, still, to belong to us. One of the reasons for this is that the kind of things he wrote are not easily re-presentable in our day. We can embrace a great novel by Dickens or Eliot or Thackeray. It can still be a part of us. One cannot do the same with the writings of Ruskin. Who reads art criticism these days? Or even 19th-century foamings at the mouth about social injustice? Who settles down to devour a public lecture delivered with force and fury, spraying out Biblical quotations to bolster its authority? And yet there is much more to Ruskin than this. Read with care, we can find a man much less one-dimensional than he was dismissed as being within 20 years of his death. Another Ruskin has emerged in the last 50 years, and this is a Victorian of quite a different and much more sympathetic stamp. He was an early ecologist, a promoter of the idea of education for women, a man who cared passionately for the environment. As Proust discovered, he found new ways of writing about the nature of memory, and, in his work on Turner, even a new approach to the crafting of biography.

Gandhi, Mahatma Mahatma Gandhi first read Ruskin's *Unto This Last* (see *Unto This Last*) – he had been given it by a friend called Henry Polak – during a long, overnight train journey between Johannesburg

and Durban in 1904. *The book was impossible to lay aside, once I had begun it,* he wrote. *It gripped me. Johannesburg to Durban was a twenty-four hour journey. The train reached there in the evening. I could not get any sleep that night. I determined to change my life in accordance with the ideals of the book.* Three years later, serving time in jail for resisting the suppression of the Indian community of South Africa, he began to translate it into Gujarati, entitling it *Sarvodaya* (Universal Uplift). *I believe that I discovered some of my deepest convictions reflected in this great book of Ruskin . . . The teachings . . . I understood to be: that the good of the individual is contained in the good of all; that a lawyer's work has the same value as a barber's, inasmuch as all have the same right of earning their livelihood from their work; that a life of labour, i.e. the life of the tiller of the soil and the handicraftsman, is the life worth living.*

> M.K. Gandhi, *An Autobiography or the Story of My Experiments with Truth*,
> ch.95, 'The Magic Spell of a Book'

Genius His parents (see **Mother** and **Father**) may have been convinced of the extraordinary qualities of mind possessed by their infant prodigy, but what of Ruskin himself? Did he believe that he was a genius? A genius of sorts is perhaps the answer. Or perhaps a compulsive, in the grip of a kind of greed of looking, would be the better answer, as he explains in this letter to his father, which was written when he was 33 years of age. He begins by taking a sideswipe at a popular novelist of that day – par for the course. *Miss Edgeworth may abuse the word 'genius', but there is such a thing, and it consists mainly in a man's doing things because he cannot help it, – intellectual things, I mean. I don't think myself a great genius, but I believe I have genius; something different from mere cleverness, for I am* not *clever in the sense that millions of people are – lawyers, physicians and others. But there is the strong instinct in me which I cannot analyse to draw and describe the things I love – not for reputation, nor for the good of others, nor for my own advantage, but a sort of instinct like that for eating or drinking.*

I should like to draw all St Mark's, and all this Verona stone by stone, to eat it all up into my mind, touch by touch.

Letter to his father, 2 June 1852

Geology Which was the earlier passion, art or geology? Ruskin's passion for geology took root very early, as a child. His father had encouraged his interest by buying him a collection of 50 minerals from a geologist in the Lake District: copper ore from Coniston, garnets from Borrowdale . . . Nothing interested him more than close-looking and classifying, whether it be minerals, leaf shapes or flowers. By the age of 12 he had began to write a mineralogical dictionary. He was forever fingering and stroking hefty chunks of this, that and the other, little of it human. When he came to open a museum in Sheffield (see **St George's Museum**), he was eager to include within its collection many specimens of his minerals. There were few things more aesthetically pleasing, instructive and sensuously rewarding.

German Art, a Flea in its Ear Ruskin had little time for modern German artists. He described their general attitude – an unattractive mixture of egotism and wilful blindness – as follows. *The artist desires that men should think he has an elevated soul, affects to despise the ordinary excellence of art, contemplates with separated egotism the course of his own imaginations or sensations, and refuses to look at the real facts round about him, in order that he may adore at leisure the shadow of himself. He lives in an element of what he calls tender emotions and lofty aspirations; which are, in fact, nothing more than very ordinary weaknesses or instincts, contemplated through a mist of pride.* The past fared a little better. He was fond of the work of the man he touchingly called *Alfred* Dürer. Perhaps to anglicise his Christian name in this way reveals an undisclosed wish to appropriate him as one of ours.

MP, vol.3, pt.4, ch.3, section 11

Gill, Eric, on Ruskin's foresight *Ruskin was chiefly thought of as an art critic, and so long as he kept to that strait and narrow way, all was well. But, unfortunately for him, he saw life more or less whole. He saw – no one else did, or very few – that art and life were bound together. He saw, he foresaw, what we now see, the complete divorce of art from life which industrialism entails. You may think all is well. Ruskin did not. 'Thou Ruskin seest me'. I speak with diffidence because I rather fancy in some sort of way he may be seeing me, and hearing me, and I am very much afraid. I am wondering whether I am really saying the truth about him. Morris saw the evil of modern industrial conditions, but he could see no remedy but the short cut of a certain sort of politics. Ruskin saw the evil, and he saw its real roots; hence the contumely with which he was greeted. The art critic should leave ethics and economics alone. To some extent the businessman worships art (especially when he is persuaded that it is a good investment), but you must not interfere with trade. Well, they have made a fine mess of it with their trading and finance. Let us remember Ruskin as the man who foretold their doom.*

From an Address at the English Speaking Union, 8 February 1934

Gothic Who were the anonymous makers of the great Gothic buildings of Venice to which Ruskin devoted so much attention? And what was their relationship to the work that they did with their own hands? Those were the revolutionary issues that Ruskin chose to address midway through the writing of *The Stones of Venice* (see **Venice**) in a section called 'The Nature of Gothic: and herein of the true functions of the workman in art'. He had shifted his attention away from the minute study of ancient buildings to the nature of work itself, and the issue of man's contentment in the workplace. The slashing art critic had turned slashing social commentator. He contrasted the pride that a medieval workman might take in what he fashioned with his own hands, often as playfully idiosyncratic as its maker, and contributing to a common form of public art, which would be on display for all to enjoy, with the

enslavement of man in the factories of England. The operative of Ruskin's day had been degraded to the level of a machine. *And the great cry which rises from all our manufacturing cities, louder than their furnace blast . . . is that we manufacture everything there except man.* It was to be a rallying cry for socialists in decades to come. William Morris (see **Morris**) published an edition of *The Nature of Gothic* for his Kelmscott Press, writing in the introduction: *the lesson Ruskin . . . teaches us is that art is the expression of man's pleasure in his labour.*

Governor Eyre of Jamaica In 1865 John Ruskin, together with his friend Thomas Carlyle (see **Carlyle**) and others, contributed £100 to a Defence and Aid Fund created in support of Governor Eyre of Jamaica. Carlyle was chair of the committee. As a favour to his friend, Ruskin did most of the work. Ruskin wrote to the *Daily Telegraph* about it, declaring himself *a Conservative and a supporter of order.* Eyre had suppressed an attack by several hundred black protestors on the Court House at Morant Bay with great violence, and at the cost of many deaths. Impeachment threatened. Eminent Victorians quickly divided themselves into two camps, the liberals and the defenders of the status quo. Ruskin, as organiser in chief for Carlyle's faction, did much of the groundwork. Others who believed that Eyre had behaved admirably included Tennyson and Dickens. It was Dickens's statement in defence of Eyre's stance that seems the most shocking now. A defender of the South during the American Civil War, Dickens was strongly of the opinion, lifelong, that it was wrong to show any *platform-sympathy with the black – or the Native or the Devil*, quite mistaken to think that *Hottentots . . . were identical with clean shirts at Camberwell.* Eyre, though forced into retirement, kept the normal pension of a former colonial governor.

<div style="text-align:right">

Daily Telegraph, 20 December 1865; David M. Levy,
*How the Dismal Science Got its Name: Classical Economics
and the Ur-Text of Racial Politics*, ch.7, p.169

</div>

Grammars In the 1870s Ruskin wrote a series of books, collectively called Grammars, whose purpose was to inculcate a respect for science and education. Their subjects were minerals, botany and birds, and their titles *Deucalion*, *Proserpina* and *Love's Meinie*. What is science? he asks. What does it do and what is it for? These books were intended to serve as useful and practical working tools for his new museum in Sheffield (see **St George's Museum**). It was all part of his effort to treat the condition of the whole man by providing him with a rounded education (see **Education**). You can imagine that Ruskin might have written *Love's Meinie* while standing on one leg, and occasionally hopping from here to there to emphasise a point.

Gray, Effie A couple of months after his 29th birthday, on 10 April 1848, John Ruskin married a handsome, voluble, energetic, 19-year-old Scottish girl called Euphemia Chalmers Gray, an effervescing creature of middling height, who had retained many of her milk teeth. The marriage was to be short-lived. It was annulled on 15 July 1854 on the grounds of his incurable impotence (see **Annulment of his Marriage**). She quickly married the painter John Everett Millais (see **Millais**), and later produced eight offspring. This statement about his impotence had, it seems, been for the public record only. Ruskin in fact denied that he was impotent, although there has been no lasting proof to the contrary. Ruskin and Effie (as she was commonly known) were remarkably dissimilar in many respects, as we discover when we read her letters written from Venice during the time that Ruskin was researching and writing yet another dauntingly wordy multi-volume masterpiece (see **Venice**). Effie thirsted after the company of human beings, handsomely epauletted specimens of young Austrian soldiery, for example; Ruskin preferred the company of dusty old books, capitals and finely sculpted cornices with powerful and intricate religious messages, often the older the better. Ruskin clambered over old buildings, and expatiated upon them

in his books at great length. Effie drooled over the clothes of men and women at balls, soirées, La Fenice opera house, and expatiated about them in her letters at great length. She was no fool – she spent a great deal of time learning German, polishing her Italian, and rather regretting the fact that her French was not quite up to the mark for the best social occasions. Her views on architecture – the wretchedness of Palladio in particular, and of the Venetian Renaissance in general – were remarkably similar to those of her husband. She does not appear to despise him. In fact, she loves him, and only flirts to a degree. He lets her out on a long string, and gets on with his work. He complains, mildly, about her *want of quietness of dress*. She finds herself amazed that he can know so much about Venice, possess such strong opinions on the subject, and speak with such authority about its long, long history, when he speaks to almost no one alive in the present, and can never recognise again the very same human being he met yesterday. She is not fully aware perhaps quite how much there is to be learnt from the silent and unmoving dead.

Guild of St George The Guild of St George was established by Ruskin in the 1870s to make England and the miserable English a little happier. Agricultural land would be acquired, and honest workers set down on it to turn the soil in a traditional fashion, interminably – with the aid of mattocks, spades and elbow grease. There was to be as little machinery as possible because *no machines will increase the possibilities of life. They only increase the possibilities of idleness.* And there was nothing to be more despised by Ruskin, that crazed workaholic, than idleness. He tried to raise money to fund the venture, but the only generous man reckless enough to support such a scheme proved to be a philanthropist by the name of John Ruskin. He put £1000 of his own money into the venture, and regarded it as a gift pure and simple. Nothing was to come back to the giver. The Guild's purpose in the longer term was to create

a National Store (see **National Store**) – the capitalists had left us with nothing but the burden of a National Debt. His words, in Letter 8 of *Fors Clavigera* (see ***Fors Clavigera***), are singingly idealistic, larded with a sentimentality that sounds both biblical and patriotic. *The money is not to be spent in feeding Woolwich infants with gunpowder. It is to be spent in dressing the earth and keeping it, – in feeding human lips, – in clothing human bodies, – in kindling human souls. First of all, I say, in dressing the earth. As soon as the Fund reaches any sufficient amount, the Trustees shall buy with it any kind of land offered them at just price in Britain. Rock, moor, marsh, or sea-shore – it matters not what, so it be British ground, and secured to us.* The only thing that stood in the way of the runaway success of the venture was the sheer bloody-mindedness of humanity, reeking, as usual, of self-interest and suspicion. For all that, the Guild of St George still exists, doing good works as an educational charity. There is a pastoral Ruskinland in the Wyre Forest, Worcestershire, where sheep can be shorn by hand, and a wondrous wildflower meadow in Gloucestershire.

Hands and Fingers Ruskin's hands were small, and the fingers surprisingly long. He held his pen between the first and second fingers when writing – most unusual (though the novelist Joseph Conrad did the same). Ruskin worried out loud about this, in a letter to his father. He should change, he thought, so that his writing would be a little more legible. But he didn't change. His first biographer (and sometime secretary), W.G. Collingwood, was mightily preoccupied by, if not touchingly, finically concerned about, Ruskin's grip, and all that it meant and would mean. *Ruskin's was all finger-grip; long, strong talons, curiously delicate and refined in form, though not academically beautiful. Those whose personal acquaintance with him dated only from the later years never knew his hand, for then it had lost its nervous strength; and in the cold weather – the greatest half of the year in the North – the hand suffered more than the head. But his*

palm, and especially the back of the hand, was tiny. When he rowed his boat he held the oars entirely in his fingers; when he shook hands you felt the pressure of the fingers, not the palm. In writing, he held the pen as we are taught to hold the drawing pencil, and the long fingers gave much more play to the point than is usual in formed penmanship.

W.G. Collingwood, *Ruskin Relics*, p.136

House-Fly, Common *I believe we can nowhere find a better type of a perfectly free creature than in the common house-fly. Nor free only, but brave; and irreverent to a degree which I think no human republican could by any philosophy exalt himself to. There is no courtesy in him; he does not care whether it is king or clown whom he teases; and in every step of his swift mechanical march, and in every pause of his resolute observation, there is one and the same expression of perfect egotism, perfect independence and self-confidence, and conviction of the world's having been made for flies . . . You cannot terrify him, nor govern him, nor persuade him, nor convince him.*

QA, pp 213–14

Houses of Parliament In a letter to *The Builder* of 9 December 1854, Ruskin describes the buildings still under construction, with their wealth of imitation Gothic detail designed by Augustus Pugin (see **Architecture**), as *the most effeminate and effectless heap of stones ever raised by man.*

Hunchback of Notre Dame by Victor Hugo
I believe it to be simply the most disgusting book ever written by man.

LEJR, vol.36, p.212

Illth Ruskin's most ingenious – and perhaps least mellifluous – coinage was the word *illth* – which means the opposite of the word *wealth*. Just as ill means the opposite of well, doesn't it? He explains at some length how he came to regard it as such an irresistible notion in *Unto This Last*

(see **Unto This Last**): *Wealth, therefore, is 'The possession of the valuable by the valiant'; and in considering it as a power existing in a nation, the two elements, the value of the thing, and the valour of its possessor, must be estimated together. Whence it appears that many of the persons commonly considered wealthy, are in reality no more wealthy than the locks of their own strong boxes are, they being inherently and eternally incapable of wealth; and operating for the nation, in an economical point of view, either as pools of dead water, and eddies in a stream (which, so long as the stream flows, are useless, or serve only to drown people, but may become of importance in a state of stagnation should the stream dry); or else, as dams in a river, of which the ultimate service depends not on the dam, but the miller; or else, as mere accidental stays and impediments, acting not as wealth, but (for we ought to have a correspondent term) as 'illth' causing various devastation and trouble around them in all directions; or lastly, act not at all, but are merely animated conditions of delay, (no use being possible of anything they have until they are dead,) in which last condition they are nevertheless often useful as delays, and 'impedimenta'.* Fully understood?

I Want, I Want, I Want . . . *I am tormented by what I cannot get, said, nor done. I want to get all the Titians, Tintorets, Paul Veroneses, Turners, and Sir Joshuas in the world into one great fireproof gallery of marble and serpentine. I want to get them all perfectly engraved. I want to go and draw all the subjects of Turner's 19,000 sketches in Switzerland and Italy, elaborated by myself. I want to get everybody a dinner who hasn't got one. I want to macadamize some new roads to Heaven with broken fools'-heads. I want to hang up some knaves out of the way, not that I've any dislike to them, but I think it would be wholesome for them, and for other people, and that they would make good crow's meat. I want to play all day long and arrange my cabinet of minerals with bright new wool. I want somebody to amuse me when I'm tired. I want Turner's pictures not to fade. I want to be able to draw clouds, and to understand how they go, and I can't make them*

stand still, nor understand them – they all go sideways . . . Farther, I want to make the Italians industrious, the Americans quiet, the Swiss romantic, the Roman Catholics rational, and the English Parliament honest – and I can't do anything and don't understand what I was born for. I get melancholy – overeat myself, oversleep myself – get pains in the back – don't know what to do in any wise. What with that infernal invention of steam, and gunpowder, I think the fools may be a puff or barrel or two too many for us. Nevertheless, the gunpowder has been doing some good work in China and India.

<div align="right">*CEN*, vol.1, pp 75–6, letter of 28 December 1858</div>

Imperialism Ruskin was an imperialist through and through. At the beginning of *The Stones of Venice* (see **Venice**), his sweeping history of the rise, triumph, decline and fall of the greatest maritime empire the world had ever witnessed, he names, with a great rhetorical flourish so characteristic of the man, the world's four great empires, three gone – Tyre, Rome, Venice – and the fourth still in the heady pride of its making: the British Empire. Some years later, on 8 February 1870, Ruskin gave his inaugural lecture as the very first Slade Professor of Fine Art at Oxford University. That lecture contained these words of exhortation at its conclusion. Britain, he declaimed to its future masters, *must found colonies as fast and as far as she is able, formed of her most energetic and worthiest men, seizing every piece of fruitful waste ground she can set her foot on, and then teaching these her colonists that their first virtue is to be fidelity to their country, and that their first aim is to be to advance the power of England by land and sea . . . These colonies must be fastened fleets, and every man of them must be under authority of captains and officers; and England, in these her motionless navies (or in the true and mightiest sense, motionless* churches, *ruled by pilots on the Galilean lake of all the world) is to expect 'every man to do his duty'*. Britain is to be the world's teacher. The task of the colonised is to be that of the grateful listener. The only crumb of comfort that the ardent,

yet now mildly dismayed, Ruskinian of our own day can glean from this statement is that Ruskin appears to be expecting it to be *fruitful waste ground* that the colonists make fruitful all over again . . . According to Kenneth Clark, a later incumbent of the chair of Slade Professor of Fine Art, an undergraduate called Cecil Rhodes who went up to Oxford soon after this lecture was delivered *regarded his copy of Ruskin's inaugural as his most precious possession.*

Kenneth Clark, *Ruskin at Oxford*, p.10

James, Henry, on Ruskin's vulnerability – *In face, in manner, in talk, in mind, he is weakness pure and simple. I use the word, not invidiously, but scientifically. He has the beauties of his defects; but to see him only confirms the impression given by his writing, that he has been scared back by the grim face of reality into the world of unreason and illusion, and that he wanders there without a compass and a guide – or any light save the fitful flashes of his beautiful genius.*

Henry James, letter to his mother, 20 March 1869

Japan Ruskin knew almost nothing of Japan. Unsurprisingly, he never visited. (Japan opened up to the West after 200 years of isolation in 1853, when Ruskin would have been 34 years old.) He even disliked the little that he knew, writing once to Bernard Quaritch the bookseller *not to send any more of those Japanese works, as they disturbed him, and it was too late for him to enter into those matters.* And to a peppery letter launched in the direction of Dante Gabriel Rossetti (see **Rossetti**), he added this: *But we won't have rows; and, when you come, we'll look at things that we both like. You shall bar Parma, and I, Japan.* Japan, failing to notice, quickly embraced his ideas, his passionate advocacy of the hand-crafting of objects, his *scientific* view of nature, his analysis of social ills. Even his love of Gothic found its echo in the new architecture of Japan. His most enthusiastic supporter was Mikimoto Ryuzo, who became Japan's

foremost Ruskinian scholar and collector, and creator of the Ruskin Cottage in Tokyo, a guild and shop that promoted the hand-crafting of work, and gave support to the unemployed.

W.M. Rossetti, *Rossetti Papers*, p.103

King, Martin Luther, a putative reader of Ruskin According to a reliable correspondent and keen Ruskinian in upstate New York, a copy of Ruskin's *Unto This Last (see **Unto This Last**)*, the four essays written in 1860 that scream for justice to be done for those oppressed by evil capitalists, was found in the library of the late Martin Luther King. No one has yet examined that copy for evidence that the great defender of civil rights ever read or profited by it. In common with thousands of other books by Ruskin down the decades, it may have been bought merely because it was known to be overwhelmingly significant.

King's College Chapel, Cambridge Ruskin the great critic could also transform himself, with the dash of his intemperate pen, into Ruskin the fool, by spewing forth opinions that were rash, ill-judged, ignorant and idiotic, and wholly lacking in the kind of application to careful looking, which he recommended to others lifelong. Here is a 19th-century tabloid view of King's College Chapel in Cambridge: *What a host of ugly church towers have we in England, with pinnacles at the corners, and none in the middle! How many buildings like King's College Chapel at Cambridge, looking like tables upside down, with their four legs in the air! What! it will be said, have not beasts four legs? Yes, but legs of different shapes, and with a head between them. So they have a pair of ears: and perhaps a pair of horns: but not at both ends. Knock down a couple of pinnacles at either end in King's College Chapel, and you will have a kind of proportion instantly.*

SLA, p.229

Labour Party, The When its first 29 members entered parliament in 1906, they were asked which had been the most influential book in their lives. The majority chose *Unto This Last* by Ruskin (see ***Unto This Last***).

La Touche, Rose In 1858, the year Ruskin fell out with the evangelical God introduced to him when he was a mere child by his pious mother (see **Bible, Year 1858** and **Mother**), he met – and subsequently fell hopelessly in love with – a ten-year-old girl called Rose La Touche, after her mother had invited him to give drawing lessons to Rose and her older sister. *A lady wrote to me, saying, as people sometimes did, in those days, that she saw I was the only sound teacher in Art; but this farther, very seriously, that she wanted her children – two girls and a boy – taught the beginnings of art rightly; especially the younger girl, in whom she thought I might find some power worth developing: – would I come and see her?* Here is how he describes their first meeting. *Rosie came in, quietly taking stock of me with her blue eyes as she walked across the room; gave me her hand, as a good dog gives its paw.* Her lips were *perfectly lovely in profile*, he wrote, years later. She thought him *so ugly*, she told him. At first, the mother encouraged the possibility of a relationship with her daughter – matters became complicated by the fact that she herself was attracted to Ruskin. Fervently religious, Rose suffered a long and very disabling breakdown after taking her first communion in October of 1863. When she reached the age of 18 (by then Ruskin was 47 years old), he proposed marriage. Rose promised to give him an answer in three years. Her instability got worse and worse, and when she refused him, and then died (in 1875), Ruskin's health broke. He records seeing her for the very last time, when she was on her deathbed. *Of course she was out of her mind in the end; one evening she was raving violently till far into the night; they could not quiet her. At last they let me into her room. She was sitting up in bed; I got her to lie back on the pillow, and she lay her head in my arms as I knelt beside it. They left us, and she asked me if she should say a hymn, and she*

said 'Jesus, lover of my soul' to the end, and then fell back tired, and went to sleep. And I left her. Is he more to be pitied than blamed? In his letters, he called her Pet (he called many things Pet, including old buildings of which he was especially fond), but there was no evidence of wrong-doing or impropriety. Dante had fallen hopelessly in love with Beatrice Portinari when she was nine years old. (He was nine years old too.) She married another. She too died young. Dante wrote *The Divine Comedy*, and beatified the girl that he could never have in the *Paradiso*. It was a happy outcome for posterity. Pitiful Ruskin could boast of no similar conflicted triumph to soothe away his misery.

PRAE, pt.3, ch.3, 'L'Esterelle', section 51 (abridged); letter to Francesca Alexander, 1887, quoted in *John Ruskin's Letters to Francesca and Memoirs of the Alexanders*, ed. Lucia Gray Swett, p.119

Lawrence, D.H., on the Ruskinian manner Those who loved Ruskin and all his works were abhorrent to the writer and poet D.H. Lawrence. Their puffed-up stuffiness made his flesh creep. He saw in them nothing but oily, self-satisfied smugness. *The deep damnation of self-righteousness . . . lies thick all over the Ruskinite, like painted feathers on a skinny peacock*, he wrote.

Kevin Jackson, *A Ruskin Alphabet*, p.48

Lawyers *I would have nothing to do with lawyers. Not one of them shall ever have so much as a crooked sixpence of mine, to save him from being hanged, or to save the Lakes from being filled up.*

HI, p.115

Leaves Ruskin was a brilliant amateur naturalist. His taxonomies, his habits of naming, categorising and dividing one thing from another, were unique unto himself, eccentric acts of sheer intellectual bravado. No wonder he and the scientists of his day were in such a state of

perpetual warfare, caught between outrage, low-level combat and mutual bamboozlement. He is at his most fanciful and Keatsianly luxuriant when writing about leaves. What other serious naturalist has ever claimed that leaves might be divisible into two kinds, *mainsails and studding-sails*? It is as if the poet long *manqué* has seized hold of the pen. He speaks of leaves with the tenderness and gentle curiosity that he seldom showers upon his descriptions of human behaviour. A leaf is something quite different, a world unto itself. Leaves are not bothersome. They do not answer back. The acutely analytical, child-like self of a middle-aged, bipolar (is this not how we might describe Ruskin now?) man of independent means and independent habits can be perfectly and happily alone and safe in the presence of a leaf under quiet observation. He writes of *leaf ministries* and of the habits of reverence that one can learn from a leaf. There are such lessons of quiet, unhurried orderliness and benignity to be learnt from leaf-builders! Leaves show a kindliness, we are told, which are not common to minerals. (What mineral had recently done Ruskin an unkindness when he expressed this sentiment?) *If you can paint* one *leaf*, he tells us, *you can paint the world*.

<div align="right">*MP*, vol.5, pt 6, ch.10, section 22 and ch.5, section 2</div>

Lecturing Many of Ruskin's later books were first delivered as public lectures. Ruskin regarded himself as a public communicator above all things else, almost as the conscience of the nation. They were secular sermons in all but name. It was his duty to speak out about the great issues of the day: the mechanisation of factories (see **Mechanisation**), the evils of capitalism (see **Capitalism**), the importance of creating buildings that would survive us. He regarded himself as a fearlessly truthful witness to the practice of public immorality on the grand scale. In 1853, according to an account in the *Edinburgh Guardian*, his manner of lecturing was colloquial and off-hand. *He has a difficulty in sounding the letter 'r'; and there is a peculiar tone in the rising and falling of his voice at*

measured intervals, in a way scarcely ever heard, except in the public lection of the service appointed to be read in churches. In 1869 he was appointed the first Slade Professor of Fine Art at Oxford. Great crowds gathered to hear him. His eccentricities were eagerly awaited and mocked – a few dance steps here or there; flapping the wings of his cloak in mimicry of a bird when lecturing on the chough. And yet these Oxford lectures were not necessarily the best of him. His mind was always too full, he always knew too much, and he let his musings wander in far too many directions. Here is a précis of one lecture from 1873, a near-faultless exercise in bafflement and self-indulgence, noted down by a disciple. Would it have been easier on the ear if he had done a little careful preparation beforehand? *The Professor begins by contrasting the Lion of St Mark's at Venice with that of Niccolo of Pisa, i.e. the Byzantine with the Gothic; the Greek art being pious, the Gothic profane, for the Byzantines gave law to Norman licence. Theseus is every inch a king as well as Edward III; the function of a Greek king was to enforce labour; that of a Gothic king to restrain rage. Greek law is of Stasy, and Gothic Ec-stasy. Theseus and Edward III are warriors, as we know; but they are also theologians, didactic kings, rather philologians, lovers of the Logos, by which the heavens and earth were made. The Byzantine lion is descended from the Nemean Greek lion. Theseus becomes St Athanase. If a bird flies under the reign of law and a cricket sings under the compulsion of caloric, perhaps the position of a college boat on the river depends on law, and the* Dies Irae *is to be announced by a steam trumpet? The sheets of the daily press in a single year would serve to enwrap the world. Read fifty-two lines from the* Deserted Village. *Greek art is all parable, but Gothic is literal. Turner belonged to the Greek school; his scarlet clouds are a sign of death. Sir Walter Scott's Diana Vernon is a symbol of Franchise – 'ver non semper viret'. 'What Diana Vernon is to a French ballerine dancing the Cancan, the 'libertas' of Chartres and Westminster is to the liberty of M. Victor Hugo and John Stuart Mill'.*

Edinburgh Guardian, 19 November 1953; Kenneth Clark, *Ruskin at Oxford,* p.6

Leonardo and his Inadequacies Ruskin was brutally dismissive of Leonardo da Vinci, and characteristically intemperate. The man's dallying with painting had been a silly decision. Engineering and botany were his real strengths. *I want to press on you to use your time at Milan in getting rid of your respect for Leonardo. He was meant for a botanist and engineer, not a painter at all; his caricatures are both foolish and filthy, – filthy from mere ugliness; and he was more or less mad in pursuing minutiae all his days . . . You will find there is really never a bit of colour of the smallest interest in Leonardo, nor a thought worth thinking, and his light and shade is always, one side light against dark, the other dark against light – and he's done for! When did you ever see either a full profile or full face by Leonardo in middle tint against light behind?*

CEN, vol.2, pp 198–9, letter of 29 July 1883

Light of the World, The Was Ruskin's judgement to be trusted when it came to works of art? Not necessarily. There is no denying the attention he gave them, or his prodigious memory for the smallest detail. Yet what could have possessed him to describe Holman Hunt's *The Light of the World* (1853–6), a creepy, maudlin depiction of Jesus approaching with his lantern, over which the painter toiled for three years, as evidence of a great revival of Christian art in Britain? It is, *I believe, the most perfect instance of expressional purpose with technical power, which the world has produced,* he wrote, *and one of the noblest works of art produced in this or any other age.* What exactly was its purpose then? To persuade people that Jesus was the saviour of the world. It worked for the painter himself: Hunt converted to Christianity during the painting of it. Ruskin would have approved of this, being such a moralist. Paintings had a job to do. Only good could come from staring hard at a depiction of Christ as *a living presence amongst us now.*

MP, vol.3, pt.4, ch.3, section 9

Lodging in Sheffield, 1880 *Here, for instance (Sheffield, 12th February), I am lodging at an honest and hospitable grocer's, who has lent me his own bedroom, of which the principal ornament is a card printed in black and gold, sacred to the memory of his infant son, who died aged fourteen months, and whose tomb is represented under the figure of a broken Corinthian column, with two graceful-winged ladies putting garlands on it.*

FC, Letter 88, p.342

Macaulay, Lord Of the historian and eminent Whig politician Thomas Babington Macaulay, Ruskin declares: *A sentence of Macaulay's . . . may have no more sense in it than a blot pinched between doubled paper.*

PRAE, pt.1, ch.12, 'Roslyn Chapel', section 251

Mad Dog Englishman *The scientists slink out of my way now, as if I was a mad dog, for I let them have it hot and heavy whenever I've a chance at them.* (See **Science and Anti-Science**.)

HI, p.87

Madness (1) What exactly does it mean, Ruskin's madness? Contemporary reports, referring to its onset, use the terminology of the day: brain fever, for example. He pushed himself too hard, always. He never stopped – until his body and his mind forced him to stop. He attributed his illness on one occasion in 1881 not to overwork at all, *but from over-excitement in particular directions of work.* His memory was prodigious, his appetite for new knowledge insatiable. His mind fired off in all directions at once – like multiple rocket launchers. *When he wants to work out a subject, he writes a book on it*, commented his wife. He suffered emotional collapse due to the sheer degree of mental and physical exertion necessitated by some of his more ambitious projects. Unhappy conclusions to affairs of the heart descended like blows of the axe. He was profoundly depressive. His swings of mood unnerved him. Though

he had many acquaintances, his own company, when fully absorbed by one or another of his hundreds of projects, often gave him much greater satisfaction. Loneliness preyed upon him. *It is a very great, in the long run, the greatest, misfortune of my life that, on the whole, my relations, cousins and so forth, are persons with whom I can have no sympathy, and that circumstances have always somehow or another kept me out of the way of people of whom I could have made friends. So that I have no friendships and no loves.* By the late 1870s, Ruskin seems almost resigned to the fact of his madness, as he suggests in this letter to his old friend Thomas Carlyle. Entirely predictably, he takes pleasure in the fact that he is able to analyse his condition, bathe it in fine words of his own choosing, spectate at it, deconstruct it into the sheer ordinariness of its component parts, rather than merely fall a helpless victim to it. *It was utterly wonderful to me to find that I could go so heartily and headily mad; for you know I had been priding myself on my peculiar sanity! And it was more wonderful yet to find the madness made up into things so dreadful, out of things so trivial. One of the most provoking and disagreeable of the spectres was developed out of the firelight on my mahogany bed-post; and my fate, for all futurity, seemed continually to turn on the humour of dark personages who were materially nothing but the stains of damp on the ceiling. But the sorrowfullest part of the matter was, and is, that while my illness at Matlock encouraged me by all its dreams in after work, this has done nothing but humiliate and terrify me; and leaves me nearly unable to speak any more except of the natures of stones and flowers.*

Letters to Dante Gabriel Rossetti quoted in W.M. Rossetti, *Ruskin: Rossetti: Pre-Raphaelitism*, 1899, pp 71, 72; letter to Thomas Carlyle, 23 June 1878, quoted in *The Complete Works of W.H. Auden, Volume 6: Prose, 1969–1973*, p.183

Madness (2), The Black Cat Exactly one week after the death of Ruskin, the following account of his first bout of illness was published in the *British Medical Journal*: *When the illness first came upon me, I seemed*

to be aware of what was about to happen. I became powerfully impressed with the idea that the Devil was about to seize me, and I felt convinced that the only way to meet him was to remain awake waiting for him all through the night, and combat him in a naked condition. I therefore threw off all my clothing, although it was a bitterly cold February night, and there awaited the Evil One. Of course all this seems absurd and comical enough, but I cannot express to you the anguish and torture of mind that I then sustained. Thus I marched about my little room, growing every moment into a state of greater and greater exaltation; and so it went on until the dawn began to break. I walked towards the window in order to make sure that the feeble blue light was really heralding the grey dawn, wondering at the non-appearance of my expected visitor. As I put forth my hand towards the window, a large black cat sprang forth from behind the mirror! Persuaded that the foul fiend was here at last in his own person, though in so insignificant a form, I darted at it and grappled with it with both my hands, and gathering all the strength that was in me, I flung it with all my might and main against the floor. A dull thud – nothing more. No malignant spectre arose which I pantingly looked for. I had triumphed! Then, worn out with bodily fatigue, with walking and waiting and watching, my mind wracked with ecstasy and anguish, my body benumbed with the bitter cold of a freezing February night, I threw myself upon the bed, all unconscious, and there I was found later on in the morning in a state of prostration and bereft of my senses.

'Mr Ruskin's Illness described by himself', *BMJ*, 27 January 1900

Mechanisation Mechanisation – which involved the toiling of large numbers of men, women and children in factories, in insanitary conditions, all slaves to giant machines – was, to Ruskin, a thing destructive of both body and soul. It robbed people of their freedom. It robbed them of their health – there was none of God's good and wholesome air in the factories of the 19th century. It robbed them of their creativity. The

presence of a machine put man at a remove from the ability to craft an object with his own hands. In short, mechanisation was a form of slavery. No machines, thundered Ruskin in the fifth letter of *Fors Clavigera* (see **Fors Clavigera**), increase the possibilities of life. They only increase the possibilities of idleness.

Metaphysicians Ruskin heartily loathed the obfuscatory writings of metaphysicians. He believed that *metaphysicians and philosophers are, on the whole, the greatest troubles the world has got to deal with; and that while a tyrant or bad man is of some use in teaching people submission or indignation, and a thoroughly idle man is only harmful in setting an idle example, and communicating to other lazy people his own lazy misunderstandings, busy metaphysicians are always entangling good and active people, and weaving cobwebs among the finest wheels of the world's business; and are as much as possible, by all prudent persons, to be brushed out of their way, like spiders, and the meshed weed that has got into the Cambridgeshire canals, and other such impediments to barges and business.* For all that, Ruskin not only attended the London meetings of the Metaphysical Society, but also read a brief paper there. Almost 50 years later, the writer Lytton Strachey captured the grave mood of those august occasions: *The Metaphysical Society . . . met once a month during the palmy years of the Seventies to discuss, in strict privacy, the fundamental problems of the destiny of man. After a comfortable dinner at the Grosvenor Hotel, the Society, which included Professor James Huxley and Professor Tyndall, Mr. John Morley and Sir James Stephen, the Duke of Argyll, Lord Tennyson and Dean Church, would gather round to hear and discuss a paper read by one of the members upon such questions as: 'What is Death?' 'Is God unknowable?' or 'The Nature of the Moral Principle'. Sometimes, however, the speculations of the Society ranged in other directions. 'I think the paper that interested me most of all that were ever read at our meetings,' says Sir Mountstuart Elphinstone Grant-Duff, 'was one on "Wherein consists the special beauty of*

imperfection and decay?" in which were propounded the questions "Are not ruins recognised and felt to be more beautiful than perfect structures? Why are they so? Ought they to be so?" Unfortunately, however, the answers given to these questions by the Metaphysical Society have not been recorded for the instruction of mankind.'

MP, vol.3, pt.4, ch.16, section 28; and Lytton Strachey, *Eminent Victorians*, p.99

Mill, John Stuart　John Stuart Mill, famous defender of liberalism, the very epitome of an enlightened humanism, and widely regarded as the greatest British philosopher of the 19th century, was described by Ruskin as the Devil incarnate, an *utterly shallow and wretched segment of a human creature*. Why so? Because Mill, in his *Principles of Political Economy* (1848) championed the kind of laissez faire economics that Ruskin so despised. That so-called science, Ruskin thundered, is not governed by natural laws. It is subject to the will of living, breathing and feeling human beings. *Among the delusions which at different periods have possessed themselves of the minds of large masses of the human race, perhaps the most curious – certainly the least creditable – is the modern soi-disant science of political economy, based on the idea that an advantageous code of social action may be determined irrespectively of the influence of social affection.* The economics of a man such as Mill would lead to one thing only: the triumph of greed and avarice, and the reduction of man himself to a covetous machine, intent on chasing nothing but some illusory notion of Progress. Men such as Mill, wrote Ruskin, descending into a description reminiscent of some Boschean nightmare, *are a strange spawn begotten of misused money, senseless conductors of the curse of it, flesh-flies with false tongues in the proboscis.* The truth was not quite so simple. Mill in fact had some sympathy for socialism. Ruskin's rage had blinded him.

UTL, Essay 1, 'The Roots of Honour'; *CEN*, vol.1, pp 233 and 245, letters of 18 August and 12 September 1869

Millais, Sir John Everett　Ruskin first wrote in praise of John Everett Millais and William Holman Hunt, those two young Pre-Raphaelites (see **Pre-Raphaelites**), in 1851. *They paint nature as it is around them*, Ruskin announced to the world, *with particular attention to facts.* Of Millais' work he said this: *He sees everything, large and small, with almost the same clearness.* Ruskin's relationship with the young Pre-Raphaelite painter was complicated by the fact that Millais' intense line of sight had evidently encompassed Ruskin's young wife Effie Gray (see **Gray**). The trio endured a tense Scottish vacation together in the summer of 1853 – conflicted emotions were evidently stirring. Millais began to paint Ruskin's portrait, posed in front of a raging burn. Ruskin stares blankly ahead, seeing nothing. It is the location itself that is painted with such a minute attention to natural detail, and to such a high degree of finish – the very geology of the rocks seems to be under close scrutiny. Millais eventually married Effie Gray in 1855. Ruskin, writing to Millais, gave the portrait a little bit more than a modicum of praise when it was finally done. *On the whole the thing is right and what can one say more – always excepting the yellow flower and the over-large spark in the right eye, which I continue to reprobate – as having the effect of making me slightly squint . . . But my father and mother say that the likeness is perfect – but that I look bored – pale – and a little too yellow. Certainly after standing looking at the rows of chimneys in Gower Street for three hours – on one leg – it is no wonder.* Millais had his studio in Gower Street, Bloomsbury, London. Further sittings – correction, standings – had evidently taken place there. John James Ruskin (see **Father**) bought the portrait for £350 on 4 December 1854. He refused to let it be exhibited. Ruskin continued to praise and to dispraise Millais' work in the aftermath of the collapse of his marriage. In 1856, reviewing the Royal Academy's summer exhibition, he said this of Millais' *Peace Concluded*: *[It] will rank in future among the world's best masterpieces; and I see no limit to what the painter may hope in future to achieve.* Millais and Effie Gray had eight children together.

The painting of Ruskin by Millais found its final home at the Ashmolean Museum in Oxford, the city that Ruskin had hoped to convert. Is that not bitterly ironic?

PRE, pp 19, 100; letter from Ruskin to his father, 11 December 1854

Modern Painters Ruskin's reputation was established at a stroke with the publication of the first volume of *Modern Painters* in May 1843, when he was 24 years old. Four further volumes were to be published, and the cycle was not completed until 1860. Ruskin's books were often interrupted affairs, a single volume gradually evolving into several. A defence of the art of J.M.W. Turner (see **Turner**) at its beginning, *Modern Painters*, a great, saggy portmanteau-like feat of verbal engineering, eventually encompassed much, much else too as Ruskin aged and matured both in his opinions and his knowledge of European art. It roamed and wandered from geology to philosophy, metaphysics to aesthetics, seemingly almost at whim. The youthful Ruskin was following his nose and his wide-ranging interests. The book was fiercely judgemental, breathtakingly eloquent and alarmingly confident in its manner. The sheer length of his sentences amazed and bamboozled. When would they ever end? Where would they land? His descriptions of individual paintings by Turner have never been equalled. The book's bold and thunderous sweeps of irreverence alarmed, infuriated, amazed and delighted in just about equal measure. How could one so young be so severe and so sure of his own opinions? How could he have learnt so much so early? Where had he discovered the sheer audacity to dismiss Claude Lorrain in this way? His Biblical studies were perhaps in part to blame – he wrote with the denunciatory severity of the preacher fulminating from the pulpit, secure in the knowledge that he has God at his back. The living painters he named and dispraised often gave as good as they got. Samuel Prout felt indignation on behalf of himself and his fellow artists; Turner was embarrassed that he had been singled out and lifted up to the skies for

such praise in this way. The critics snapped at Ruskin's heels, but scarcely tried to penetrate seriously the maze of his ever shifting arguments. His father bought him a great painting by Turner, *The Slave Ship*, as a token of his esteem. The infant prodigy was making good!

Money Ruskin, a very rich man indeed due to the hard work and business acumen of his father (see **Father**), loathed money and the lending of it out at interest. Money did not really exist it all, in Ruskin's views, it was a phantasm, *a chronic abstraction*, as he once put it in *Fors Clavigera* (see ***Fors Clavigera***), which slithered about the world like a venomous snake, poisoning at random. *The first of all English games is making money. That is an all-absorbing game; and we knock each other down oftener in playing at that than at football, or any other roughest sport; and it is absolutely without purpose; no one who engages heartily in that game ever knows why. Ask a great money-maker what he wants to do with his money, – he never knows. He doesn't make it to do anything with it. He gets it only that he may get it. 'What will you make of what you have got?' you ask. 'Well, I'll get more.' Just as, at cricket, you get more runs. There's no use in the runs, but to have more of them than other people is the game. And there's no use in the money, but to have more of it than other people is the game. So all that great foul city of London there, – rattling, growling, smoking, stinking, – a ghastly heap of fermenting brickwork, pouring out poison at every pore, – you fancy it is a city of work? Not a street of it! It is a great city of play; very nasty play, and very hard play, but still play.*

CWO, Lecture 1, pp 31–2

Morris, William William Morris first read Ruskin at Oxford around 1853, when he was 19 years old. The social criticism set him on fire. A new prophet had been born. As an undergraduate, Topsy (as he was fondly known due to his unruly mop of hair), would half-sing, half-chant Ruskin's words out loud to his friends. He cut through Ruskin's

rhetorical flourishes, and saw through to the revolutionary message at its heart: work with the hands should not be separated from work with the head; a designer could and should also be a maker; division of labour in a factory led only to boredom, idleness and dehumanisation; the blind worship of materialism was an empty dream. Both men were poets. Morris wrote poetry unstoppably. Letting it gush from the pen seemed all too easy. Unlike Ruskin's, some of it was very good – 'The Haystack in the Floods', for example. When reprinting Ruskin's 'The Nature of Gothic' (see **Gothic**) as a book for his Kelmscott Press, Morris praised its message to the skies: *In future days it will be regarded as one of the very few necessary and inevitable utterances of the century,* he wrote in the introduction. Ruskin had evoked and championed the spirit of the independent artisan.

Mother It is difficult to underestimate the influence that Margaret Cox, Ruskin's mother, had upon his life. She shaped him. She moulded him. She pampered and cosseted him from cradle to grave. When away from home, he would regularly write letters back to his parents, explaining how devotedly attentive he was always being. Is it enough, dear ma, dear pa? *I am always happy when I am most dutiful,* wrote the grateful son. The very pious daughter of the landlady of a pub in Croydon, south London, Margaret's character is put on full display in a portrait by James Northcote – severely bonneted, beaky of nose. She wanted her son to aim for the skies. Would he be a bishop or a poet? As a child she had him learn great gobbets of the Bible by heart (see **Bible**), and these gobbets, often incomprehensible to all but the most biblical-scholarly of readers, are always forcing their way into the prose of his mature years. He soon burgeoned as an extravagantly precocious child beneath her watchful eye. Cartography and then geology consumed him. When Ruskin took up residence at Oxford as a gentleman-commoner, Margaret took rooms in the High Street too so that she could attend to his every need – which

would have included ensuring that he did not fall under the influence of the Oxford Movement. Oh, the dangerous shadow of Catholicism! (See **Religion**.)

Mountains, Beneficence of Mountains – and especially his beloved Alpine mountains – overwhelmed and over-awed Ruskin. They were sacred haunts, places of refuge. He observed them from afar or clambered up them with plumb-line, tape measure and notebook in hand, always annotating, always sketching, forever in a mood of headlong excitability. He subjected them to intense and exhaustingly minute geological scrutiny. He found them difficult to draw, difficult to apprehend in their entirety (their appearance, depending upon where you chose to stand, was forever changing), and almost impossible not to worship. He also mocked all those painters before Turner who had either been incapable – or perversely unwilling – to do them justice in their paintings. He admired the way God had sculpted them, with a beneficent eye. He acknowledged that it was a well nigh impossible task, such was their here-and-gone complexity, for any artist to do them justice. *Of all the various impossibilities which torment and humiliate the painter, none are more vexatious or more humiliating than that of drawing a mountain form.* As with so much else in the natural world he also comically anthropomorphised them, transforming fiercesome peaks into gentle, treading-oh-so-lightly custodians by emphasising their capacity for delicate forethought: *It can hardly be necessary to point out [their] perfect wisdom and kindness, as a provision for the safety of the inhabitants of the high mountain regions. If the great peaks rose at once from the deepest valleys, every stone which was struck from their pinnacles, and every snow-wreath which slipped from their ledges, would descend at once upon the inhabitable ground, over which no year would pass without recording some calamity of earth-slip or avalanche; while, in the course of their fall, both the stones and the snow would strip the woods from the hill sides, leaving only*

naked channels of destruction where there are now the sloping meadow and the chestnut glade.

<div align="right">

MP, vol.4, pt.5, ch.14, section 19, and ch.13, section 12

</div>

Music Ruskin had fairly popular tastes in music. He preferred it to be artless, he argued as a young man, and relatively unsophisticated – the most touching of all melodies came from the aeolian harp, played by the wind, and next to that, the Alpine horn. He hated Mendelssohn, and enjoyed Mozart. He had a fierce dislike of the repulsive modernity represented by the headlong crash, bang, wallop of Wagner's *Meistersinger* (see **Wagner's *Die Meistersinger von Nürnberg***). He adored the romping music of pantomime, the histrionic excitements of popular opera. He even attempted to write a tune or two of his own. There were musical interludes in the evenings at Brantwood (see **Brantwood**) during the 1880s. (Sir Charles Hallé, founder of the Hallé Orchestra, and inventor of a mechanical page-turner, played one of Ruskin's Broadwood pianos there.) *The evening's entertainments, having begun with a reading by Ruskin from a favourite novel by Sir Walter Scott or Miss Edgeworth* – read from the very chair, his first biographer tells us, in which he preached his baby sermon – *would usually continue with music. There might be a little composition or two of his own ('Old Aegina's Rocks' or 'Cockle Hat and Staff'), followed by his cousin Joan's Scotch ballads or some Christy Minstrel Songs, the latest ditty fresh from London,* and then, surprise, surprise, you might witness the Prophet himself *clapping his hands to 'Camptown Races' or the 'Hundred Pipers',* with the rest of the household joining in on the rousing chorus.

<div align="right">

W.G. Collingwood, *The Life of John Ruskin*, p.345

</div>

Myth-Making *Effie had some of her friends to tea last night – but I only condescended to go in at the end of the evening – to prove that I was not a* myth.

<div align="right">

Letter to his father, 26 November 1851

</div>

Naples and the Neapolitans Was Ruskin more in favour of Northern than Southern Europe? His contempt for Naples and the Neapolitans takes some beating. On 20 April 1874, he described it as *certainly the most disgusting place in Europe I was ever forced to stay in*, populated by *nests of human caterpillars.* If only he had spotted some badly treated donkeys or mangy street cats in the back streets of the old town to fall in love with! (See **Animals**.)

> Edward Chaney, *The Evolution of the Grand Tour:*
> *Anglo-Italian Cultural Relations Since the Renaissance*, p.145

National Store (To Include Potted Shrimps and Pickled Walnuts)
The possession of such a store by the nation would signify, that there were no taxes to pay; that everybody had clothes enough, and some stuff laid by for next year; that everybody had food enough, and plenty of salted pork, pickled walnuts, potted shrimps, or other conserves, in the cupboard; that everybody had jewels enough, and some of the biggest laid by, in treasuries and museums; and, of persons caring for such things, that everybody had as many books and pictures as they could read or look at; with quantities of the highest quality besides, in easily accessible public libraries and galleries.

> *LEJR*, vol.28, p.641

Nature No one praised Nature more highly, and more breathlessly, than the young Ruskin. His repeated experiences of travelling through Alpine scenery by coach as a young man led to moods of exultation, and to prose of a great and giddy soaringness. Nature was the very embodiment of God himself. Awestruck by the divine presence amongst landscape, Ruskin regarded Nature as a benign and healing force, expressive of the fullness of God himself, and one moreover that seemed to possess unparalleled organisational powers. He praised the least little thing, from a leaf to a snow drift, from a soodling stream to a soaring escarpment. The generous hills instruct us. And we should thank them for it. *There was a*

continual perception of Sanctity in the whole of nature, from the slightest thing to the vastest; an instinctive awe, mixed with delight; an indefinable thrill, such as we sometimes imagine to indicate the presence of a disembodied spirit. I could only feel this perfectly when I was alone; and then it would often make me shiver from head to foot with the joy and the fear of it, when after being some time away from hills, I first got to the shore of a mountain river, where the brown water circled among the pebbles, or when I saw the first swell of distant land against the sunset, or the first low broken wall, covered with mountain moss. More troublingly intrusive was the human element. It had no right to be there. *We do not want chalets and three-legged stools, cow-bells and butter-milk*, he wrote. *We want the pure and holy hills.* Two decades later, Nature turned her back on him. He lost his faith in her. (What is more, his increasing fame as a writer led to his opinions about these hidden places being spread far, far too widely. Mass tourism, and all the destructiveness of the treasured, peaceful Old that comes in its wake, was on the march, and Ruskin, characteristically, wrote of it with no small contempt.)

MP, vol.3, pt.4, ch.17, section 19

Nature's Betrayal Once Nature had been his guardian, his custodian, his helpmate, his guide. Then, in the 1870s, Nature betrayed herself, and betrayed the man who had believed in her. Ruskin, ever a man of heightened feeling and extreme swings of mood and opinion, regarded Nature's behaviour as an act of personal treachery, almost as an act of violence against himself. *Of all the things that oppress me, this sense of the evil working of nature herself – my disgust at her barbarity – clumsiness – darkness – bitter mockery of herself – is the most desolating. I am very sorry for my old nurse, but her death is ten times more horrible to me because the sky and blossoms are dead also . . . No spring – no summer. Fog always, and the snow faded from the Alps.*

CEN, vol.1, p.226, letter of 3 April 1871

Ouch! Ruskin's fearless dismissals of paintings he regarded as inferior in ambition or execution – he seldom wrote about sculpture unless it was attached to a building – could be rapier-like swift, sharp and brutal. Sometimes he would lull the artist into a false sense of security and premature self-satisfaction by offering a few mild words of praise before drawing out his glinting blade. Imagine him wandering around the Royal Academy Summer Exhibition year after year (see **Royal Academy**), and sizing up the helpless victims of his keen eye. Here is a smattering of those comments.

Having offered 150 words of general praise for a painting by J.F. Lewis entitled *An Armenian Lady* seen at the Royal Academy Summer Exhibition in 1855 – *everything is exquisitely, ineffably right* – he concludes with this sentence: *It is only to be regretted that this costly labour should be spent on a subject devoid of interest.*

On *The Prosperous Days of Job* by W.C.T. Dobson: *Does Mr Dobson really see Nature as always white and buff – or does he think Buff a specially sacred colour? In my mind, it is associated chiefly with troopers' jerkins.*

On a William Holman Hunt drawing of grapes: *When not on the vine, grapes are precisely the dullest fruit that can be painted; and I can only advise, or beg, any reader who is inclined to attend to me, never in future to buy any of Mr Hunt's grapes. He wastes an inconceivable quantity of time on them, and this is the fault of the public, for the grapes always sell.*

On *The Highland Scene* by Mr Richardson, seen at an exhibition of the Society of Painters in Water Colours, 1857: *He seems to have a good eye for colour; there is a very pretty piece of speckled grey in the square rock on the right at the bottom; but he is not at the slightest trouble to fit the colours of shadows to the lights, or of dark sides to light sides: and his ungrammatical brilliancy will therefore always look only what it is – very pretty warm colour, but never like sunshine.*

PRE, pp 62, 109, 118 and 153

Oxford Ruskin's time as an undergraduate at Christ Church College, Oxford University, was practically a family affair. His father visited regularly. His mother took lodgings in the High Street so that she could look after him. His parents (see **Mother** and **Father**) liked nothing better than to meddle in their son's affairs, and Ruskin, ever the dutiful son who was eager to please, happily went along with it. His health being fragile lifelong (he had a poor chest, and an endemic weakness of the spine, which would cause a distinctive stoop in later life), he was expected to spend his evenings with mother, and to be in bed by 10 pm. He overworked. Adèle-Clotilde Domecq rejected him for another (see **Baroness Duquesne**). In spite of the fact that he won the prestigious Newdigate Prize for Poetry, he did not especially shine at Oxford. His Latin prose was deficient, and he eventually graduated with a degree of questionable importance – an honourable double fourth. At least he could now call himself A Graduate of Oxford.

Paedophilia There is not a scrap of evidence to suggest that Ruskin had an inappropriate interest in the bodies of children. Given that he was a strong believer in the effect of sin upon fallen human nature, could it be that he both admired, and perhaps hopelessly longed for the return of what he regarded as the innocence of, childhood? And yet there is at least one book by him, *Ethics of the Dust* (1865), which would make any reader feel slightly squeamish for its strange primness and silliness and awkwardness of address. The book is a series of lectures, often in arch dialogue, first delivered at Winnington Hall, a girls' school *deep in the country* (of Cheshire), which he visited regularly. It deals with crystallography, mineralogy, the Pyramid builders, morality and much else by-the-by – in fact, a characteristically bizarre and flitting-all-over Ruskinian mix. The Old Lecturer (his own description of himself) patronises the girls, makes silly jokes, plays odd verbal games, presents improbable scraps of dialogue. And yet, for all its oddness, the dear old

man (in fact, he was in his forties when he visited) never seems to be at risk of doing them harm. He is merely, as he puts it, trying to *awaken in the minds of young girls, who were ready to work earnestly and systematically, a vital interest in the subject of their study. (See* **La Touche**.)

Palladio *The architecture of Palladio is wholly virtueless and despicable,* commented Ruskin, with characteristic brute force, in the third volume of *Modern Painters (see* **Modern Painters***)*. What exactly was wrong with the great architect? He was a Renaissance man (see **Renaissance**), and Ruskin despised the Renaissance. Palladio's buildings epitomised the rigidities of classicism. The workers were mere copyists, little better than the mechanised slaves *(see* **Mechanisation***)*, who were obliged to toil in the factories of Ruskin's own day; their forerunners, in fact.

MP, vol.3, pt.4, ch.5, section 4

Paradise Child Ruskin, relatively companionless (but see **Child-hood**), fell in love with the garden at the back of the family house in Herne Hill, then south of London. It was his first paradise, and roaming in it, close-scrutinising its trees and fruits and flowers, quickened his lifelong passion for botany which, late in his writing life, led to *Proserpina* (1879), his rather eccentric study (to give it its poignant, extended title) *of wayside flowers among the Alps, and in the Scotland and England which my father knew*. Named after the Roman fertility goddess, whose cult was associated with fruit and flowers, the book was all about these *pretty mysteries (as opposed to the vulgar and ugly mysteries of the so-called science of botany)*. The very title of the book was guaranteed to haunt him: he called Rose La Touche (see **La Touche**), the ten-year-old child with whom he fell in love, Proserpine too. *Our house had a back-garden, renowned all over the hill for its pears and apples, and possessing also a strong old mulberry tree, a tall white-heart cherry tree, a black Kentish one, and an almost unbroken hedge, all round, of alternate gooseberry and current*

bush, decked, in due season, with abundant fruit. The differences of primal importance which I observed between the nature of this garden, and that of Eden, as I had imagined it, were, that, in this one, all the fruit was forbidden, and there were no companionable beasts: in other respects the little domain answered every purpose of Paradise to me.

PRAE, pt.1, ch.2, 'Herne Hill Almond Blossoms', sections 38 and 39 (abridged)

Piracy Ruskin was very, very particular about his books and their presentation. He took a keen interest in typefaces (he favoured pica modern), spacing, quality of paper, readability, the number of words on a page, word breaks. He wanted a book – like Nature (see **Nature**) – to be something beautiful, a delight to own and to handle. The man who became his trusted publisher, George Allen, had once worked as his engraver. Allen's editions of Ruskin's works became the standard ones. The publishing house of Allen and Unwin flourished well into the 20th century. But the dissemination of Ruskin's words were not entirely within his own control, and nothing enraged him more than the pirated editions of his works that were published in America from the 1850s onwards, often without his proper authorisation – or any remuneration whatsoever. Ruskin may not have visited the place, but his words had crossed the Atlantic, and there was a great demand for them there. The practice deepened his settled conviction that America was a barbarous and uncivilised place.

Penguins *When I begin to think at all I get into states of disgust and fury at the way the mob is going on (meaning by mob, chiefly Dukes, crown princes, and such like persons) that I choke; and have to go to the British Museum and look at Penguins until I cool. I find Penguins at present the only comfort in life. One feels everything in the world sympathetically ridiculous; one can't be angry when one looks at a Penguin.*

CEN, vol.1, pp 100–101, letter of 4 November 1860

Philanthropy Due to the fact that his father was a canny business-man (see **Father**), Ruskin was an enormously wealthy man. He spent the generous allowance he received from his parents during their life-time with great ease, scattering it abroad like some antique Venetian *nonna*, vested all in black, tossing crumbs to the pigeon in St Mark's Square. And then, on the death of his father in 1864, he inherited a further £120,000 (the equivalent of approximately £15 million now), together with various properties. Ruskin spent this inheritance with great liberality, too. He established and endowed the Ruskin School of Drawing at Oxford. He gave money to the painter Dante Gabriel Rossetti (see **Rossetti**), an on-and-off friend whom he cajoled, joshed and bullied into making the kind of work that Ruskin believed he should be making. He also gave an annual stipend to Lizzie Siddal, artist, poet, model and muse to the Pre-Raphaelite Brotherhood (see **Pre-Raphaelites**). He presented the Ashmolean Museum in Oxford with a gift of 50 watercolours by Turner, and he gave a further 25 to the Fitzwilliam Museum in Cambridge in order, perhaps, to prove his even-handedness. He subsidised a housing project run by the social reformer Octavia Hill. He set up a tea shop. He gave the city of Sheffield, where he created a museum (see **Sheffield** and **St George's Museum**), a huge quantity of work, from paintings to minerals, prints to missals. He bought a farm, which caused him endless trouble (see **Totley**). Eventu-ally, Ruskin was left with little more than the income from his many, many books, the sales of which became healthier and healthier during his lifetime.

Poetry His parents had willed it and wished for it. Was not their extraordinarily precocious son destined to be a poet? He wrote large quantities of the stuff from a very early age. His first poem was written before he reached his seventh birthday, and it was a tale of a mouse in seven neat, regular couplets called 'The Needless Alarm'. When on his

continental travels, he would often keep one notebook in verse and another in prose. At Oxford, he seemed to be on the brink of achieving his ambition to become a poet whose gifts would be universally recognised when he won the university's annual Newdigate Prize for Poetry. He then continued to write poetry until, at some point mid-way through the many volumes of *Modern Painters* (see **Modern Painters**), he made a strange and heartfelt confession: he had been reading the poems of Keats again, and he knew that he would never be his equal. The only solution was to stop pretending. And so he stopped, but poetry from his pen kept sputtering back into life from time to time (he wrote a *tour de force* in passable verse called 'The Teaching of Architecture in Our Schools' in 1865, for example), and he would number amongst his acquaintances most of the celebrated poets of the day (see **Browning** and **Tennyson**), and express strong opinions about the quality of what they were writing, often to their extreme exasperation. Here is the barbed arrow of a letter he loosed off in the direction of the Poet Laureate, Alfred Lord Tennyson, after the publication of *Idylls of the King*, his cycle of poems about the Arthurian legends: *Treasures of wisdom there are in it, and word-painting* [Ruskin loathed reading his own descriptions of paintings described as word-paintings] *such as never was yet for concentration; nevertheless it seems to me that so great power ought not to be spent on visions of things past, but on the living present. For one hearer capable of feeling the depth of this poem I believe ten would feel a depth quite as great if the stream flowed through things nearer the hearer. And merely in the facts of modern life – not drawing room, formal life, but the far-away and quite unknown growth of souls in and through any form of misery or servitude – there is an infinity of what men should be told, and what only a poet can tell. I cannot but think that the intense, masterful, and unerring transcript of an actuality, and the relation of a story of any real human life as a poet would watch and analyse it, would make all men feel more or less what poetry was . . . This seems to me the true task of the modern poet.* Eventually Ruskin's own poetry was gathered up

and published in books. And the critical view of its general quality? Ghastly. Terrible.

<div style="text-align: right">Letter to Alfred, Lord Tennyson, September 1859</div>

Politics Ruskin's politics are a bit of a puzzle. He seems to face Left, Right and Centre. The German communist philosopher Friedrich Engels and the Italian revolutionary Giuseppe Mazzini admired him. Socialists such as William Morris (see **Morris**) cheered him on as one of their own. He was not. Generally speaking, he hated politicians. He thought they were scoundrels on the make. He was not a man for parties. He regarded the democratic process with contempt. *Men only associate in parties by sacrificing their opinions, or by having none worth satisfying; and the effect of party government is always to develop hostilities and hypocrisies, and to extinguish ideas.* At times he called himself *the reddest of the reds*, and at other times *a violent Tory of the Old School.* In 1880, during the nomination process for the Rectorship of the University of Glasgow (Ruskin was not chosen), he was asked whether he preferred Lord Beaconsfield or Mr Gladstone. His response was characteristically combative. *What in the devil's name . . . have you to do with either Mr D'Israeli or Mr Gladstone?* he replied. *You are students at the University, and have no more business with politics than you have with rat-catching. Had you ever read ten words of mine with understanding, you would have known that I care no more for either Mr D'Israeli or Mr Gladstone than for two old bagpipes with the drones going by steam, but that I hate all Liberalism as I do Beelzebub, and that, with Carlyle, I stand, we two alone now in England, for God and the Queen.* So how do we pigeon-hole the man? We do not. He was never a party-political animal. He never voted in his life. He was a fierce believer in hierarchy; one of the curses of the present day (his present that is), he opined, was the belief that you could rise out of your class and into a higher one. Nonsense, thought Ruskin. This rigidity did not make him unable to sympathise with those whom he would have regarded as his

social inferiors. He bled for the injustices they suffered. He howled in prose over stories in the press of the miserable lot of the poor. What is more, he agitated – by word for the most part, and less so by deed – to improve social attitudes towards the nature of work. Work must be rewarding. And those who set others to work had a responsibility to those they employed to ensure that the work they did was not exploitative. Factories brought into being a form of slavery (see **Mechanisation**). Work must above all be the creative expression of every individual.

W.G. Collingwood, *The Life of John Ruskin*, p.371

Potter, Beatrix, spots a future guinea pig Beatrix Potter was just 17 years old when she spotted Ruskin at the Royal Academy in London (see **Royal Academy**). The experience of seeing him there in 1884 – by which time he would have been 65 years of age – was so extraordinary that she wrote about it in her journal on 5 March as follows: *Ruskin was one of the most ridiculous figures I have seen. A very old hat, much necktie and aged coat buttoned up on his neck, humpbacked, not particularly clean looking. He had on high boots, and one of his trousers was tucked up on the top of the other one. He became aware of this half way round the room, and stood on one leg to put it right, but in doing so hitched up the other trouser worse than the first one had been.* It is possible that Potter put that high blue neckcloth of his to good use in later life as a writer herself. In *Appley Dapply's Nursery Rhymes* she draws the guinea pig with a blue neckcloth, and gives him a blue book too. Here is the verse that accompanied the picture: *There once was an amiable guinea-pig,/ Who brushed back his hair like a periwig –/ He wore a sweet tie,/ As blue as the sky –/ And his whiskers and buttons/ Were very big.*

Praeterita Ruskin set to work on *Praeterita*, the autobiography that proved to be his most readable work, at the suggestion of a friend, Charles Eliot Norton, during the 1880s, when his analytical powers were failing. His cousin Joan Severn (see **Severn**) both helped him with it, and

censored his words. It was serialised, but never completed. A spasmodic, unsystematic, impressionistic and only partially truthful account of his life, it lingers long over his earlier years, and spares much less time for the achievements of his maturity. It is an un-driven work too, a tale told with ease, humour and an evident pleasure in its telling. Lacking the old combativeness, it showed his admirers and his antagonists alike that Ruskin was capable of writing in a way that no longer seemed to suggest that he was in the demonic grip of the pressure of baleful circumstances.

Pre-Raphaelites Ruskin first saw the work of the Pre-Raphaelite Brotherhood in 1850, and was soon sounding off in their defence in furious letters to *The Times*, then an organ of some repute. What did he so admire about them? (Several were new graduates of the Royal Academy Schools.) Their bold use of local colour, for one. Their close observation of the Facts of Nature, which might include minute attention to the painting of individual flowers. As he wrote in *The Times*, *they will draw either what they see, or what they suppose might have been the actual facts of the scene they desire to represent, irrespective of any conventional rules of picture-making.* He so much loved their *boundless love and patience*, the fact that they painted what he described as truth rather than opted for formalism or a misty idealism, and that the models they used were real people. Ruskin hated generalised or idealised scenes. Above all things else, they were laying the foundation for a *true sacred art* in an age of creeping scepticism and faithlessness. Unfortunately, his support often came at a huge cost to the peace of mind of the artist. He would tick them off, often painting by painting – no critic was more excoriatingly attentive, brushstroke by brushstroke, than Ruskin. One year Millais' efforts (see **Millais**) at the Royal Academy Summer Show showed evidence of genius (*I see no limit to what the painter may hope in the future to achieve*); the next year he was under the lash for disgracefully betraying his own talents. Ruskin was such an opinionated bully. He couldn't resist bossing artists around, ranting at

them about how to make the most of their gifts (or lack of them). He wrote an entire book called *Pre-Raphaelitism*, which begins with a long introduction about the nature of true work. One or two of the Pre-Raphaelites get a brief mention thousands of words into the argument, and then appear again, fleetingly, thereafter. This, too, is entirely typical of the man. He could never stick to the point. His digressions were the stuff of legend years before he went mad altogether.

Prince of Wales, The, on Ruskin and architecture　*If this generation builds badly, then it leaves a blight for generations. Ruskin said that 'When we build, let us think we build for ever', a point worth making when people speak widely about sustainability but less about its true meaning, which I believe to be about recovering that which is timeless – indeed, sacred.*

From a speech delivered at the Housing Corporation Conference, Brighton, by Charles, Prince of Wales, in February 1999

Productivity　Ruskin's work patterns remained unchanged throughout the productive periods of his life: feverish activity followed by ill health or nervous collapse. He would have several projects on the go simultaneously: books, lectures, schemes for social improvement. His mind was never capable of remaining satisfied by one thing alone. It had to move in several directions at once, like some wind-fanned forest fire. On 17 November 1869, he lists his current preoccupations in a letter to Charles Eliot Norton:

> 1. Every day he writes *a little of his botany*, by which he means a book to be called *Cora Nivalis* [later to become *Proserpina*], which will introduce young people to the study of Alpine and Arctic flowers.
> 2. He is translating Chaucer's *Dream of the Rood* from medieval English into something simpler and more intelligible. He is also

translating a book of medieval French verse, *Cent Ballades*, into simple English. He has completed 57 of them.

3. He is preparing a new edition of *Sesame and Lilies* for publication, which will include the adding of new material.

4. He is doing a series of natural history drawings for use in Oxford schools.

5. Having been appointed the first Slade Professor of Fine Art at Oxford, he is writing a series of seven lectures for the spring term.

6. He is writing two papers on agates, and overseeing the illustrations for the December and January issues of a geological magazine.

7. He has been giving lessons in French, Italian and drawing to various pupils.

8. He is learning how to play musical scales correctly. He has a music master twice a week, and practises half an hour a day.

9. He is reading the memoirs of the French historian Jean-François Marmontel to his mother.

CEN, vol.1, p.253, letter of 17 November 1869

Proust, Marcel In 1901 Marcel Proust, who would go on to write *Remembrance of Things Past*, one of the greatest works of fiction of the 20th century, translated *The Bible of Amiens* – a late work by Ruskin which describes Amiens Cathedral in exacting detail – into French. Ruskin liked nothing better than to 'read' Gothic masterpieces of the Middle Ages, stone by stone by stone. Proust did the work with the help of his mother, who was a better-equipped linguist than he to deal with the niceties and convolutions of Ruskin's English. Proust loved the headily seductive forward-surgings of Ruskin's prose, which was both highly intellectual and impressionistic at the same time, revealing how

places and things could be all the more powerfully present to us when re-fashioned by memory than when actually seen. *My admiration for Ruskin*, Proust wrote, *gave such an importance to the things he has made me love that they seemed to be charged with a value greater even than that of life.* For all his swoony admiration, a part of Proust mightily distrusted Ruskin, too. When visiting Venice, he took along with him Ruskin's *The Stones of Venice* as a companion guide (see **Venice**). Proust points out that Ruskin's rhetorical flights of fancy about the downfall of Venice had aestheticised the subject. The dazzle of Ruskin's own words had caused him to fall into self-delusion and insincerity. His very brilliance had turned him into a bit of a self-admiring, self-preening liar. For all that, Proust's own style often reads like a parody of Ruskin's.

Pubic Hair The nonsense of Effie Gray's pubic hair (see **Annulment of his Marriage**) has been an on-and-off issue amongst serious Ruskin scholars, unserious commentators and complete ignoramuses for decades. Did he or did he not see her pubic hair for the first time on their wedding night? (Surely he'd had a glimpse of the stuff in those pornographic images that were shared around by the toffs at Oxford? See **Aristocracy**.) Was he horrified and disgusted by the sight of her unclothed to such an extent that it froze him? Was the difference between the flesh of a real woman and the marmoreal-smooth renderings of Greek sculptors and idealising painters too much for his over-sensitive, ever-mother-protected self? Who can ever know? In fact, can we know anything? When the marriage was annulled, on 15 July 1854, the reason given was *incurable impotency* – but this bald statement flatly contradicts what Ruskin himself had told his own lawyer. In spite of this fact, Ruskin made no attempt to defend the action. When the marriage was annulled, two doctors testified to the fact that she was still a virgin. There is also this baffling tease of a statement from Ruskin. *It may be thought strange that I could abstain from a woman who to most people was so attractive. But*

though her face was beautiful, her person was not formed to excite passion. On the contrary, there were certain circumstances in her person which completely checked it. What – and perhaps where – were these mysterious circumstances? Idle speculation may have to suffice.

Public Good Ruskin believed in Public Good. His wish was to create a National Store (see **National Store**) rather than a National Debt. No believer in Liberty or Liberalism, he described himself as an illiberal, with a powerful wish to destroy the bad things on this earth, amongst which he counted: most of the railroads of England and all the railroads of Wales (see **Railways**); the Houses of Parliament (see **Houses of Parliament**); the National Gallery; the East End of London; the north suburb of Geneva; and the city of New York. *I want to keep the fields of England green and her cheeks red; and that girls should be taught to curtsey, and boys to take their hats off when a Professor or otherwise dignified person passes by; and that Kings should keep their crowns on their heads, and Bishops their croziers in their hands.*

FC, Letter 1, p.5

***Punch* on Ruskin** This bit of doggerel from the satirical magazine *Punch* in 1856 reminds us what an impact a critical notice by Ruskin – a thumbs up or a thumbs down – could have on an artist's reputation in Victorian England:

I takes and paints,
Hears no complaints,
And sells before I'm dry;
Till savage Ruskin
Sticks his tusk in.
And nobody will buy.

Railings, Iron *The unprincipled and uncomfortable parts of a country would be where people lived among iron railings . . . Your iron railing always means thieves outside and bedlam inside, – it can mean nothing else than that. If the people outside were good for anything, a hint in the way of fence would be enough for them; but because they are violent and at enmity with you, you are forced to put the close bars and the spikes at the top . . . And yet farther, observe that the iron railing is a useless fence – it can shelter nothing, and support nothing; you can't nail your peaches to it, nor protect your flowers with it, nor make anything whatever out of its costly tyranny; and besides being useless, it is an insolent fence; – it says plainly to everybody who passes – 'You may be an honest person, – but, also, you may be a thief: honest or not, you shall not get in here, for I am a respectable person and much above you; you shall only see what a grand place I have to keep you out of – look here, and depart in humiliation.'*

<div align="right">

TP, Lecture 5, 'The Work of Iron, in Nature, Art, and Policy'

</div>

Railways Ruskin absolutely detested the railways. The noise of trains passing through beautiful countryside utterly destroyed nature's tranquillity. The railway system was vulgar, ugly and destructive. His vision is fevered, apocalyptic: *The very quietness of nature is gradually withdrawn from us; thousands who once in their necessarily prolonged travel were subjected to an influence, from the silent sky and slumbering fields, more effectual than known or confessed, now bear with them even there the ceaseless fever of their life; and along the iron veins that traverse the frame of our country, beat and flow the fiery pulses of its exertion, hotter and faster every hour.*

<div align="right">

SLA, pp 359–60

</div>

Railway Station In spite of the fact that Ruskin expressed a very voluble dislike of rail travel and everything with which it was associated – railway architecture, for example – he travelled regularly by train to

and from his home in the Lake District (see **Brantwood**), and struck up such an acquaintanceship with the station master at Coniston that he once presented him, as a mark of his appreciation, with a five-volume set of *Modern Painters* (see ***Modern Painters***). The gift seems to have been reciprocated: a railway lamp from that station still hangs today in one of the windows at Brantwood, installed there in 2000. *It is the very temple of discomfort, and the only charity that the builder can extend to us is to show us, plainly as may be, how soonest to escape from it. The whole system of railroad travelling is addressed to people who, being in a hurry, are therefore, for the time being, miserable . . . It transmutes a man from a traveller into a living parcel.*

SLA, p.220

Railways Round Dieppe *Of all the beastly, blockheady, loggerheady, doggish, loggish, hoggish-poggish, filthy, fool-begotten, swindler-swallowed abominations of modern existence – the Railways round Dieppe beat the world. I can't possibly get from here to Amiens in less than seven hours!*

Letter to Joan Severn, 1880

Religion You cannot keep the Christian religion out of Ruskin. It shaped him, from first to last. His mother was excessively pious (see **Mother**). His knowledge of the Bible was encyclopedic (see **Bible**). His writing is often close to preaching: stern, didactic, full of certitudes driven in like nails, as if delivered from a high pulpit with the aid of a megaphone. His books often consist of numbered paragraphs, as if they are so many lessons to be learned or texts to be committed to memory. The god he worshipped was Protestant and evangelical in the beginning – as his mother decreed. In *Modern Painters*, his multi-volume defence of J.M.W. Turner, which he began to write as a very young man (see ***Modern Painters***), god is in Nature. Nature was the very embodiment of the Godhead, expressive of all His fullness (see **Nature**). Later, Ruskin

suffered a profound crisis of faith. How was Ruskin to reconcile the Protestant god of his childhood and growing with the god of Catholicism, the god that seemed to have been behind the great Italian painters he so much admired, such as Tintoretto (see **Tintoretto**)? He suffered a crisis of faith (see **Year 1858**) at the age of 29. The god of his later life was a more nebulous being altogether, more pantheistical, a sponsor of goodness and the good life. He dabbled in spiritualism. God was still there, but he was not quite so personal and breathing-close any more.

Renaissance Ruskin had no time for the Renaissance. He regarded its art as debased, pagan, and symptomatic of a moral decline from which the 19th century was still suffering, and from which the future would continue to suffer. And yet his views are also confusing, if not confused. Ruskin's Renaissance is not quite our Renaissance. It begins later for a start. It has been shifted forward by at least a century. For Ruskin, the Renaissance begins in the 16th century. He praises Tintoretto (see **Tintoretto**) and Titian, those artists we would normally regard as being part of the Renaissance. He gives a very specific date for the death of the arts of Venice: 1594. That happens to be the year of the death of Tintoretto. To Ruskin, the idea of the Renaissance meant rigidity, working to order. The result was enslavement, the death of creativity. It reminded him of what was happening in the factories of the 19th century (see **Mechanisation**).

Renaissance Buildings of Venice *[A]mongst the worst and basest ever built by the hands of men . . . hardly otherwise defined than as the perpetuation in stone of the ribaldries of drunkenness.*

SV, vol.3, p.107

Reputation At the height of his reputation towards the end of the 19th century, Ruskin was regarded not only as the most important and

influential art critic of the day, and one of the greatest masters of English prose, but as a seer and a sage. How his writings had ranged and roamed! Was there anything that the mighty intellect of Ruskin had not encompassed? Soon after his death in 1900, a five-volume popular edition of *Modern Painters* (see ***Modern Painters***) was published by the Everyman Library. Its introduction refers to the beauty of his words, his nobility, and the 'sense of greatness infused in it by his own individuality' – the very fact of its having been written by John Ruskin was to be, it seems, a guarantor of its greatness. Editions of his books from his publisher and former pupil George Allen, leather-bound with marbled edging, authoritatively scriptural in their presentation, sold in their thousands. He seemed to be an unassailable eminence. Then, when the new century dawned, his collected works in 39 volumes, a monument of scrupulous scholarship undertaken by a barrister and a publisher (see **Cook and Wedderburn**), began to appear, published between 1903 and 1912, and they proved to be a disaster from a sales point of view. Then came the Great War, which seemed to mark a great divide between past and present. Modernity arrived, with a saggy knapsack of pessimism on its back. Ruskin seemed to belong to a different, much more distant and florid, age altogether. Such verbosity! Such moralising! Such endlessly laughable rhetorical bluster! The man seemed to be wholly out of key with the times. He receded into the bewhiskered sepia of his photographic portraits. His lofty and imperious prose was that of a bygone era. There seemed to be a pressing need for a different kind of writing altogether, something humbler, less elevated, less blustery, less self-assured altogether. In recent years, there has been something of a revival. What he had foreseen as a writer has edged to the fore. Was he perhaps, in his vivid descriptions of changes in the weather, a prophet of climate change? In urging people to treat nature with respect, was he not an early environmentalist? Was not his horror of hunting and vivisection a modern attitude too? Are not so many of his causes – his emphasis upon

the healing power of nature (see **Nature**), his appeal for good building (see **Architecture**), his agitation on behalf of public education (see **Education**) – our causes too?

Roads, Digging Up Ruskin was very keen on physical labour. To heave a loaded spade about contributed to man's well-being. When Slade Professor of Art at Oxford University in 1874, he conceived a scheme to involve undergraduates in the digging up and repairing of a stretch of poorly maintained road in North Hinksey, a little village just outside Oxford. The scheme was supervised by David Downes, Ruskin's faithful gardener. Crowds turned out to look. Drawings of the chaps at work in their straw hats and long johns appeared in the local press. The sight of all those sweat-soaked, road-digging toffs (Oscar Wilde was amongst their number – see **Wilde**) precipitated a storm of laughter and incredulity, and contributed to the notion that Ruskin was an eccentric oddball. Before work began, Ruskin organised a hearty breakfast for the labouring men. At one of these breakfasts he mentioned his wish to have an important book by Xenophon translated from the Greek into English. Alexander Wedderburn (later a Q.C., Ruskin's literary executor, and co-editor of the *Library Edition* of Ruskin's collected works in 39 volumes – see **Cook and Wedderburn**) volunteered for the task. Others of the Hinksey Diggers also became men of renown: Arnold Toynbee, economist; W.H. Mallock, author of the 1877 novel *The New Republic*.

Rogers's *Italy* At the age of 13, Ruskin was given a birthday gift of a book that changed the direction of his life – no longer would he be destined to become a poet or a bishop, or dream of taking over from Sir Charles Lyell as the chairman of the Geological Society. The book in question, very fashionable in its day, was an illustrated edition by a best-selling poet called Samuel Rogers. The poetry was complemented by little vignettes of Italian scenes, which were by an older contemporary

called J.M.W. Turner (see **Turner**). Ruskin began to copy them. This book of poetry, complemented by Turner's tiny black and white images, *helped to determine the entire direction of my life's energies.*

LEJR, vol.35, p.29

Rome, His Detestation of At the age of 21, as Ruskin reports in a letter to Rev. T. Dale, the head of a day school in Camberwell he had attended for three years, he found himself completely disappointed and disgusted by his first visit to Rome. The Capitol was a *melancholy rubbishy square,* the Forum a group of *smashed columns,* and the Colosseum a *public nuisance.* Sixteen years older and wiser, later, writing to his American friend Charles Eliot Norton, Ruskin partially regrets those harsh words of that *sickly and very ignorant* youth, but only partially . . . *When I now think of Rome,* he declares, *these are my incontrovertible and accurate conclusions: that the streets are damp and mouldy where they are not burning; that the modern architecture is fit only to put on a . . . cake in sugar; that the old architecture consists chiefly of tufo and bricks; that the Tiber is muddy; that the Fountains are fantastic; that the Castle of St. Angelo is too round; that the Capitol is too square; that St Peter's is too big; that all the other churches are too little; that the Jews' quarter is uncomfortable; that the English quarter is unpicturesque; that Michael Angelo's Moses is a monster; that his Last Judgement is a mistake; that Raphael's Transfiguration is a failure; that the Apollo Belvedere is a public nuisance; that the bills are high; the malaria strong; the dissipation shameful; the bad company numerous; the Sirocco depressing; the Tramontana chilling; the Levante parching; the Ponente pelting; the ground unsafe; the politics perilous, and the religion pernicious. I do think, that in all candour and reflective charity, I may assert this much.*

CEN, vol.1, p.25, letter of 28 December 1856

Rossetti, Dante Gabriel *Rossetti does such absurd things in the midst of his beautiful ones that he'll never get the public with him. He has just been and*

painted a Madonna with black hair in ringlets, like a George the 2nd wig, and black complexion like a mulatto . . . not that he meant that, but he took a fancy to the face. It was on-and-off, the friendship between Ruskin and Dante Gabriel Rossetti. They met in 1853, and taught painting together at the Working Men's College (see **Working Men's College**). Ruskin liked what he saw in Rossetti's studio, coveting his drawings *as much as I coveted Turner's*, he told him. Ruskin became a generous patron, agreeing to buy Rossetti's annual output of drawings – up to a certain figure. He did the same for Lizzie Siddal, whom Rossetti was to marry, advancing her £150 a year. Ruskin donated a basketful of fresh cut white roses from his own garden so that Rossetti could perfect the melodrama of the top right-hand corner of a painting called *Lady Lilith*. He also commissioned Rossetti to do a portrait of him for a friend, which dragged on for years. Eventually a preparatory drawing in red crayon was done, very much in the Rossetti manner. Ruskin called it *the horriblest portrait I ever saw of a human being*. Rossetti was no kinder about Ruskin. He nicknamed him *Roughskin*, and much later, scarcely lamenting his former friend's absence, wrote to his muse, Jane Morris: *I wish I had more news – for instance such tidings as that Ruskin was hanged, or something equally welcome.*

CEN, vol.1, p.101, letter of 4 November 1860; *Dante Gabriel Rossetti and Jane Morris: Their Correspondence*, J. Bryson (ed.), p.127, letter of 24 December 1879

Royal Academy, The In mid-Victorian England, Ruskin was the unofficial critical policeman of the Royal Academy Summer Exhibition. Between 1855 and 1859 he published his verdicts on the works of individual painters in a series of annual pamphlets. *Twenty years of severe labour devoted exclusively to the study of art*, he tells us in the preface to these *Academy Notes, have given me the right to speak on the subject with a measure of confidence.* Much hinged on Ruskin's praise or blame (see ***Punch***). The difference between poverty and riches, success or failure, for example (see **Whistler**). Yes, he was widely regarded as the great, current arbiter

of taste. Ruskin could be short and sharp and dismissive – or he could be very voluble indeed. There was no one with the courage to warn him to write less. No one would dare. As usual, he observed what fell under his scrutineering eye with great minuteness, advising the onlooker on one occasion to *bring a small opera-glass with you*. One painting, he tells us, consists entirely of *slops and blots*. On another occasion, he ticks off William Holman Hunt for feeling too intensely as he painted *The Scapegoat*. He might have done better to heed that piece of advice himself. He announces, witheringly, that there is an appetite amongst the general ignorant public for pictures that mean precisely nothing. Dutch pictures, as so often, come in for verbal abuse. They are *traitorous to the royalty of human nature*, he tells us, with empty-headed vehemence.

Rudeness There were few people better at rudeness and ingratitude than Ruskin. When the councillors of Sheffield suggested that the collection of objects he had gathered together for his new museum in the city (see **St George's Museum**) might be put on display in its own new museum, he dismissed Councillor Bragge's offer with breathtaking contempt. *My 'museum' may perhaps be nothing but a two-windowed garret, but it will have in it nothing but what deserves respect in art and admiration in nature. A great museum in the present state of the public mind is simply an exhibition of the possible modes of doing wrong in art, and an accumulation of uselessly multiplied ugliness in misunderstood nature. Our own museum at Oxford is full of distorted skulls, and your Sheffield ironwork department will necessarily contain the most barbarous abortions that human rudeness has ever produced with human fingers.* No one knew better than Ruskin, evidently.

Sheffield Daily Telegraph, 7 September 1875

Ruskin Centenary Conference at Coniston, 7 August 1919 *The Yorkshire Post* reported the event with all the ridiculously puffed up, strait-laced,

pseudo-Ruskinian phoney eloquence that it could muster: *There are others who stay the dusty progress of their motor-cars, among them many Americans, and alight to pop into the Ruskin Museum, submit a few remarks and queries, sweep the majestic environs of Coniston Water with a passing superficial glance, and depart. These later omit, of course, to detect the spirit of Ruskin that broods over this nestling village, an impression which is valid in respect of the greatness of the man, whether or not they subscribe to his teachings. It is true that a lively imagination gives credence to this impression, but how subtly is fancy kindled by the towering crags which flaunt their jagged charms to lure the climbers, the gaunt bleakness of the hills and woodlands which ascend with noble gesture? How plausibly, too, does Coniston Old Man essay to furnish conviction that Ruskin's spirit is consecrated here as he rears his hoary head, with its intellectual slope, to engage in his ancient pastime of noiseless warfare with the clouds, which, as today, transferred his poll into a misty battlefield. The Old Man dominates the landscape, and provides the major feature of the view from Brantwood across the lake from which that other old man was wont to look in his declining years.* Other visitors to Coniston have 'popped into' the churchyard to pay their homage to Ruskin's grave, with its rearing headstone and, to their horror, have found themselves looking at what they have often misconstrued as a swastika. The truth is as follows: there is no swastika, in the modern sense, on Ruskin's gravestone. The emblem is an ancient sun symbol, bringing good luck. The symbol on Ruskin's gravestone faces left, whereas the symbol adopted by the Nazis (some time after Ruskin was dead) faces right.

Ruskin, John Born in the same year as Queen Victoria, John Ruskin (1819–1900) was the pampered and hot-housed only child of a lifelong partnership between John James Ruskin (see **Father**), a Scots importer of sherry, and Margaret Cox (see **Mother**), the excessively pious daughter of the landlord of a pub in Croydon, south London. Although he grew up in south London, most of his schooling took place at home,

and the boy had few companions other than a feisty cousin called Mary Richardson (see **Childhood**). This relative isolation perhaps explains why he retained, lifelong, a mild Scots accent. The boy grew accustomed to being and thinking (and analysing his own thought processes) on his own, and his exceptional precociousness moved first in the direction of cartography, and then geology. He was thought to be destined for a life high in the hierarchy of the church – or perhaps he would be a poet. Reading and learning passages from the Bible by rote under the fiercely concentrated eye of his mother (see **Bible**) occupied much of his time, and his prose style shows the extent to which the orotundities of the King James Bible had an impact upon both the boy's style and his sense of himself. He often writes as if he is preaching at his audience (see **Verbosity**), laying down truths that it would be almost folly to dare to contradict. The words of the Bible are his bulwark, and a source of his tone of immense authority. In 1835 he went with his parents on the first of many tours of the Continent. Nature engulfed him. Two years before, he had received the gift of a book-length poem illustrated by the artist J.M.W. Turner (see **Turner**). This gift changed the direction of his life (see **Rogers's Italy**). His name would be linked with Turner's for the rest of his life. In 1837 he went up to Christ Church, Oxford as a gentleman-commoner (see **Oxford**). His family went with him, *en masse*. After Oxford, he began writing *Modern Painters* (see ***Modern Painters***), a defence of J.M.W. Turner, which began as a letter and concluded, 16 years later, as a multi-volume survey of such issues as the nature of creativity, the geology of mountain ranges, the painting traditions of Western Europe, and much else. Many other books followed. Art, once his chief concern, became displaced by social issues. He was appointed the first Slade Professor of Fine Art at Oxford. He retired to Brantwood (see **Brantwood**) in the Lake District to avoid the clamour of his increasing fame. Unhappy affairs of the heart (see **La Touche**), over-work, and violent opposition to his views all contributed to a mental collapse (see

Madness), which reduced him to virtual silence for the last decade of his life. He died at Brantwood on 20 January, 1900.

Ruskin, Tennessee In 1895 a town was built by a group of ardent socialists in Tennessee, and it was named after the prophetic figure of John Ruskin, who had by then declined into the silence of his bath-chair beside Coniston Water in the Lake District (see **Years of Silence**). Ruskin, though no Socialist himself, had taught these American disciples, through his writings, the truths of Socialism and collective endeavour. They published books and pamphlets, and in 1896 proposed to offer to *a reading constituency of 100,000 a week . . . [a] series of special articles by thoroughly representative socialists of all nations, under the general title of 'Ruskin Labor Letters to American Working-men.'* The group of disciples called themselves the Ruskin Co-operative Association. Being mere Americans, and living in a half-savage country, goodness knows how uncouth they were (see **America**).

Scavenger (of Old Stones) Ruskin, in common with many other great Victorians, was a bold scavenger. If he found an old building under restoration, he would rescue discarded bits of its original fabric, and have them shipped back to England. Was this cultural looting? No one stopped him. No one cared enough. The stores of the Ruskin Collection in Sheffield contain fragments of green marble from the original floor of St Mark's Basilica in Venice, for example, rescued from almost certain destruction when the building was restored in the middle of the 19th century. Here is an account of an even more ambitious (and remarkably inexpensive) acquisition, as he tells it in a letter from Abbeville dated 30 September 1868: *I have bought to day, for five pounds, the front of the porch of the Church of St James. It was going to be entirely destroyed. It is worn away, and has little of its old beauty; but as a remnant of the Gothic of Abbeville – as I happen to be here – and as the church was dedicated to my*

father's patron saint (as distinct from mine) I'm glad to have got it. It is a low arch – with tracery and niches, which ivy, and the Erba della Madonna, will grow over beautifully, wherever I rebuild it.

W.G. Collingwood, *The Life of John Ruskin*, p.253

Science and Anti-Science Ruskin deplored the habits and methods of contemporary scientists. He felt that no human mechanism – a microscope or even a pair of spectacles, for example – should be allowed to come between man and the extraordinary uniqueness of the world. He preferred the kinds of disciplines – the observational rigour and the methods of classification – which had been the hallmark of the pre-Darwinians. He rejected anatomical analysis. To see by any means other than the human eye was a futile endeavour. Scientists were far too dispassionate and far too sceptical, far too unfeeling, far too lacking in delicate reverence. They failed to acknowledge the awe-inspiringness of creation, thus robbing it of its mystery. Creation, in their view, was merely an object to be pulled apart without love or passion. *A flower is to be watched as it grows, in its association with the earth, the air, and the dew; its leaves are to be seen as they expand in sunshine; its colours, as they embroider the field, or illumine the forest. Dissect or magnify them, and all you discover or learn at last will be that oaks, roses, and daisies, are all made of fibres and bubbles; and these again, of charcoal and water; but, for all their peeping and probing, nobody knows how.*

PRAE, pt.2, ch.10, 'Crossmount', section 200

Scorn As Ruskin's mental health deteriorated (see **Madness**), so his responses to correspondents grew increasingly unpredictable. Who would expect to receive from a man of 67 such a brutal response as the following to a request for financial help from a church? *Sir, I am scornfully amused at your appeal to me, of all people in the world the precisely least likely to give you a farthing! My first word to all men and boys who care to hear me*

is *'Don't get into debt. Starve and go to heaven – but don't borrow. Try first begging, – I don't mind, if it's really needful, stealing! But don't buy things you can't pay for!' And of all manner of debtors, pious people building churches they can't pay for are the most detestable nonsense to me. Can't you preach and pray behind the hedges – or in a sandpit – or a coal-hole – first? And of all manner of churches thus idiotically built, iron churches are the damnablest to me. And of all the sects of believers in any ruling spirit – Hindoos, Turks, Feather Idolaters, and Mumbo Jumbo, Log and Fire Worshippers, who want churches, your modern English Evangelical sect is the most absurd, and entirely objectionable and unendurable to me! All which they might very easily have found out from my books – any other sort of sect would! – before bothering me to write it to them. Ever, nevertheless, and in all this saying, your faithful servant, John Ruskin.* This letter was promptly sold for £10, of which its recipient received £1.

> Letter of 19 May 1886, quoted in W.G. Collingwood,
> *The Life of John Ruskin*, pp 383–4

Scott, Sir Walter Ruskin loved the novels of Scott lifelong (such notions of gloriously exalted kingship!), and the older he got, the more dear to him he became. He even collected and pored over his manuscripts. When in old age, he especially recommended the Waverley novels to girls. *I should like all girls whatever to bathe in Scott daily, as a sort of ever-rolling, ever-freshening sea*, he wrote in a letter to Margaret Ferrier Young, a former governess to the La Touche family (see **La Touche**), in 1884.

> *LEJR*, vol.37, p.493

Servants Anne, the servant who had nursed the precious and precocious John as a babe in 1819, had lived with the family ever since, and finally died more than 50 years later, in 1871, when Mrs Ruskin was in her 90th year. Her dogged devotion was recorded by Ruskin in *Praeterita*,

his autobiography (see **Praeterita**). *She was never quite in her glory unless some of us were ill. She had also some parallel speciality for saying disagreeable things, and might be relied upon to give the extremely darkest view of any subject, before proceeding to ameliorative action upon it. And she had a very creditable and republican aversion to doing immediately, or in set terms, as she was bid; so that when my mother and she got old together, and my mother became very particular about having her teacup set on one side of her little round table, Anne would observantly and punctiliously put it always on the other: which caused my mother to state to me, every morning after breakfast, gravely, that if ever a woman in this world was possessed by the Devil, Anne was that woman.* Ruskin's first biographer, his friend W.G. Collingwood, describes the general attitude of the Ruskin household towards their servants. It displayed a *gloomy Calvinism tempered by benevolence. It was from his parents that Mr Ruskin learned never to turn off a servant, and the Denmark Hill household was as easy-going as the legendary 'baronial' retinue of the good old times. A good friend asked Mrs Ruskin, in a moment of indiscretion, what such a one of the ancient maids did, – for there were several without apparent occupation about the house. Mrs Ruskin drew herself up and said, 'She, my dear, puts out the dessert.'*

W.G. Collingwood, *The Life of John Ruskin*, p.282

Severn, Joan Twenty-three years before his death, John Ruskin gifted Brantwood and its contents (see **Brantwood**) to his cousin Joan Severn, who had long been his faithful housekeeper, companion and, in his last days, principal carer. His demands were incessant. They exchanged 3,000 letters when he was travelling – he needed the comforting umbilical cord of her distant presence even when in Italy or France. On the instructions of Joan, the house was increased in size around the original modest farmhouse, and her own family (with its attendant staff) grew too. She had five children with her husband Arthur Severn, a mediocre landscape painter whom Ruskin had the

good tact never to insult. *The Yorkshire Post* published an interview with her at Brantwood on 12 August 1919, almost two decades after Ruskin's death. The question of what Ruskin had bequeathed was evidently still gnawing away at her. *Mrs Severn thought it important to make known that Ruskin made the deed of gift of Brantwood to herself and her husband, and appointed them to look after his general business in the event of future illnesses. 'Many people,' she commented 'used to misunderstand things. But it was a thoroughly legal document which he had drafted in London without telling us anything about it.'* In 1910, Joan Severn had sold a 'sketch' by Tintoretto from Ruskin's collection to the Metropolitan Museum of Art in New York for £10,000 (the equivalent of £1,145,000 these days). Perhaps another child was on the way.

Shaw, George Bernard, on Ruskin as revolutionary thinker *If you read sociology . . . you will find that the nineteenth century poets and prophets who denounced the capitalism of their own time are much more exciting to read than the economists and writers on political science who worked out the economic theory and political requirements of socialism . . . Ruskin in particular leaving all the professed socialists – even Karl Marx – miles behind in force of invective. Lenin's criticisms of modern society seem like the platitudes of a rural dean in comparison . . . I have met in my lifetime some extremely revolutionary characters; and quite a large number of them, when I have asked, 'Who put you onto this revolutionary line? Was it Karl Marx?' have answered, 'No, it was Ruskin.'*

<div align="right">George Bernard Shaw, The Intelligent Woman's Guide to
Socialism and Capitalism, Appendix, p.469</div>

Sheffield In the 1870s Ruskin, ever the passionate idealist, conceived a scheme to open museums in the English regions. Just one was subsequently opened, in Sheffield (see **St George's Museum**), and he filled it with objects from his own enormous collection of books, missals,

paintings, prints, minerals and much else. Why Sheffield? Because he admired its workers in iron, believing them to be unsurpassed in their hand-crafting skills. He also thought them noble and pious in a way that reminded him, somewhat fancifully, of the traditional virtues of good, Olde-English stock. The decision was a brave – or perhaps reckless – one on his part because Sheffield was a city renowned for its political radicalism, and Ruskin, a fragile intellectual, light of voice, with a mild Scots accent, and never more than ten stone in weight until the infirmities of old age confined him to a bath-chair and condemned him to corpulence (see **Years of Silence**), was never a party-political animal (see **Politics**). His ambition was to teach these workers necessary lessons in the appreciation of beauty, man-made and natural, to raise them up, to educate them (see **Education**). And to better their basic human lot by coaxing them out of the horrifying pollution of a fast-growing industrial city by siting the museum on a hill overlooking scenery that was reminiscent of his beloved Alpine vistas. He visited Sheffield very seldom, and there is no record of any prolonged conversations between worker and master. He bought the small cottage, which would house all these objects sight unseen, and installed one of his pupils, Henry Swan (see **Swan**), as its first curator. He then went on to buy a small farm on the edge of the city in order to encourage agricultural work of a collaborative nature, work that would not exploit the worker. The museum was a success. Local people came from streets nearby; other visitors, such was Ruskin's renown, arrived from China and Australia. The experiment with the farm ended unhappily – Ruskin found himself tangled in disputes with local radicals, even Communists (see **Totley**).

Sherry Was Ruskin a drinker? Yes. And he was even drunk from time to time. *I am velly velly drunk* he concluded a letter to his cousin Joan Severn. He could hold his liquor too. He drank gallons of his father's sherry (see **Father**) in his time, and he always kept a good cellar at Brant-

wood (see **Brantwood**). His very last meal consisted of pheasant and champagne. Every year on his birthday, 8 February, a toast was drunk to his health by the family. The sherry on that occasion came from a consignment of special Amontillado from *H.M.S. Victory*, blended to Lord Nelson's particular taste (Napoleon had his own special blend too), a few barrels of which were purchased by his father after the death of the admiral. The barrel had Nelson's name on it. The *Victory* had put into Cadiz harbour to pick up the sherry from the Ruskin family firm not long before the battle of Trafalgar. One important constituent of sherry is of course brandy. Nelson's body was preserved in brandy immediately after his death before being shipped back and transferred to a lead coffin. John James Ruskin had many special sherries, wines and ports in his cellar to which John would have had access, from Cockburn and Harris Ports to Muscatel and Paxarete (a sweet wine used for blending). Thirty bottles of his *very old* sherry were sold to Queen Victoria on one occasion for £87 16s.

St George's Museum The small museum that Ruskin opened in Walkley on the outskirts of Sheffield in 1875 – funded with his own money, staffed by his indefatigable disciple Henry Swan (see **Swan**) and full of objects owned by him or commissioned from other artists – was a social experiment. His wish was to better the lot of the workers in iron for which the city had been renowned since the days of Geoffrey Chaucer in the 14th century, when a *Sheffield thwitel* (knife), handily kept down the miller's sock for swift and ready access, was mentioned in the *Canterbury Tales*. Paintings could be examined for proof of the greatness of the fine and often wayward detailing of Gothic architecture (see **Gothic**); specimens of minerals would help to teach the rudiments of geology (see **Geology**); illustrations of animals and birds by the likes of Edward Lear and Audubon (see **Audubon and Other Feathered Friendships**) would encourage a true appreciation of the marvellously eccentric variousness

of living things. These were objects designed to transport the onlooker into the presence of places, buildings and objects he could never hope to visit. It was a collection with an educational goal – and there were many books too, many of them by Ruskin himself, which would give additional keys to the understanding of Nature's bewildering variety, its flowers, birds, minerals. And just outside the cottage, which was sited on a hill abutting some of the finest scenery in England, Nature herself was available for the worker to wander in at will. There was nothing Ruskin believed in more passionately than the importance of closely observing flowers, trees, birds, rocks, landscape. Nature was the flinging out of God's bounty in its entirety, as he regarded it when a young evangelical Christian under the strict tutelage of his despotic mother. Until Nature herself turned sullen and threatening on him.

Stormy Weather The weather of the early 1870s seemed to provide Ruskin with solid proof that the times were out of joint, that *a moral darkness had descended upon a nation that had blasphemed the name of God deliberately and openly; and had done iniquity by proclamation, every man doing as much injustice to his brother as it was in his power to do*. For many years he had kept track of weather patterns in his journals, and from about 1871 and on, he became aware of a 'plague wind' that blew from all points of the compass, along with dirty skies and an unusual chill . . . God was evidently unhappy, proclaimed Mr Ruskin, his prophet. Or was this evidence of climate change caused by industrial pollution?

From a lecture delivered at the London Institution, 4 February 1884

Style In spite of the fact that the name of Ruskin is generally associated with the kind of rhetorical prose that thunders and rolls ever onward like the indomitable ocean, awe-inspiringly challenging – if not repellent – in its complexity and obscurity, and often waywardly, if not wilfully, digressive, this was not always the case. His prose tended

to adapt itself to circumstance. It also changed as he aged. You can often find him regretting the pulpit windbaggery of his youth. His sentences get shorter, pithier as he ages. At times he can be as snappily savage and ironic as Swift. He can also be self-revelatory to an unusual degree, and never more so than when in correspondence with his American friend Charles Eliot Norton. In his letters to Norton, we can feel what the pain of being himself, this extraordinarily gifted bipolar depressive (as we might well diagnose him were he alive now) actually felt like, tormented by self-doubt, emotionally raw in the extreme for all his intellectualism. Who exactly is this man born John Ruskin? And what is he to become? The polysyllabic blusterer falls away, leaving us to observe a man alone with the bare simplicities of his chilly, all too human predicament, and often spiced with a degree of humorous self-mockery. How obsessively he monitors his own fluctuating moods. And how interesting that it has taken an American to open him up! *I'm as alone as a stone on a high glacier, dropped the wrong way, instead of among the moraine. Some day, when I've quite made up my mind what to fight for, or whom to fight, I shall do well enough, if I live, but I haven't yet made up my mind what to fight for – whether, for instance, people ought to live in Swiss cottages and sit on three-legged or one-legged stools; whether people ought to dress well or ill; whether ladies ought to tie their hair in beautiful knots; whether Commerce or Business of any kind be an invention of the Devil or not; whether Art is a Crime or only an Absurdity; whether Clergymen ought to be multiplied, or exterminated by arsenic, like rats; whether, in general we are getting on, and if so where we are going to; whether it is worth while to ascertain any of these things; whether one's tongue was ever made to talk with or only to taste with.*

CEN, vol.1, pp 84–5, letter of 15 August 1859

Swan, Henry Henry Swan had been a pupil of Ruskin's at the Working Men's College in Red Lion Square, London (see **Working Men's**

College). When Ruskin established his museum in Sheffield (see **St George's Museum**), he invited Swan and his wife to run it. Swan was already living there. Like Ruskin, he was an eccentric, with a wide range of enthusiasms. A keen cyclist, he threw the boomerang, practised Crystal Cube Photography (an early form of stereoscopy), developed his own system of shorthand in competition with Pitman's, invented a new system of musical notation, practised Quakerism, vegetarianism and teetotalism, and lectured visitors to the museum at great length, in a style reminiscent of the professor himself. Ruskin's Speaking Book in all but name, he was often a source of great exasperation.

Teeth Ruskin was much preoccupied by his teeth. In January of 1867 he made a drawing of the mahogany-coloured bar that supported his dentures for a dentist called Alfred Woodhouse based in Conduit Street, London. The drawing is surrounded by much text, and all drawn and written in a fever of self-preoccupation. He had been about to be fitted for some new dentures, but had missed the appointment. So Ruskin, by way of a preliminary, treated the dentist to a breathless account from the very thick of the field of battle. This is what he would have to sort out when his patient eventually turned up, he explained: *You will have a good deal to do; for I've been practising with the teeth and I find my long exposed upper tooth is hardly any use and the teeth catch and strain that more than the back ones – on which they grate with a sound of death's head and cross bones,* through *one's meat, – and to my horror, I find that the food accumulates more in* front *from the front teeth not being so much used – so that I could never eat before people . . . What did you make me all that mahogany bar round my mouth – merely to hold one bit of ivory . . . for? It's like the chain of the Alps at Turin in summer, when all the snow's gone except a dot on Monte Viso?* After that work was done, he had trouble from time to time, requiring bathing his teeth in brandy on one occasion, and losing a few more here and there. In common with the rest of mankind, he did

not exactly relish the prospect of going to the dentist. *Set to work to finish* Punch *lecture with prospect of teeth scraping all the afternoon*, he told his diary in the late autumn of 1883.

Tennyson, Lord Alfred The two were friends of sorts and mutual admirers. Ruskin once described Tennyson as the greatest living English poet, though he didn't like the ending of *Maud*. Tennyson's young wife Emily could not wait to read *The Stones of Venice* (see **Venice**), although she confided to her husband that she disagreed with Ruskin's definition of architecture. Both men favoured the Gothic in architecture over the neoclassical, though the fact that Tennyson and his wife chose to buy a house called Farringford on the Isle of Wight displeased Ruskin greatly. (It was the success of *Maud* that had enabled Tennyson to purchase the house in the first place.) *I don't believe in chalk and sand*, Ruskin grumbled, *and you have nothing else on the Isle of Wight*. He would have preferred that they build on rock or, better still, have opted for a *granite habitation*. The main reason for the choice was Tennyson's craving for utter solitude. Ruskin would surely have concurred. When an illustrated edition of Tennyson's poems was published, the sight of which, according to Ruskin, caused Tennyson to *shake like the jarred strings of a harp*, Ruskin himself responded with surprising tact, remarking merely that there was *much to be said for making people think and puzzle a little*.

Ann Thwaite, *Emily Tennyson: The Poet's Wife*, p.323

Tintoretto *There is none like him, none!* wrote Ruskin of Tintoretto, the great Venetian painter of the cinquecento, whose enormous – in both size and emotional impact – cycles of religious paintings he had encountered in the Madonna dell'Orto, a little-visited church beside one of the more remote Venetian canals. Ruskin, given his febrile, delicate and excitable nature, was often overwhelmed by works of art. They punched him in the solar plexus. They meant more to him than most human

beings. Such was Ruskin's reverence for Tintoretto, that he dated the abrupt end of 300 glorious years of Venetian art to the year of his death: 1594. That sight of those giant Tintorettos, soaring to such a great height around the high altar, almost induced a return to the evangelical certitudes of his youth. After seeing many more Tintorettos – and especially his *Crucifixion* – at the Scuola Grande di San Rocco, he tried to explain and describe to his father the extreme nature of his response: *I never was so utterly crushed to the earth before any human intellect as I was today, before Tintoret. Just be so good as to take my list of painters, and put him in the school of Art at the top, top, top of everything, with a great big black line to stop him off from everybody. He took it so entirely out of me today that I could do nothing at last but lie on a bench and laugh. As for painting, I think I didn't know what it meant until today – the fellow outlines you your figure with ten strokes, and colours it with as many more. I don't believe it took him ten minutes to invent and paint a whole length. Away he goes, heaping host on host, multitudes that no man can number – never pausing, never repeating himself – clouds and whirlwinds and fire and infinity of earth and sea, all alike to him.*

Letter to his father from Venice, 24 September 1845

Tolstoy, Leo, on Ruskin's prescience *Ruskin was one of those rare men who think with their hearts, and so he thought and said not only what he himself had seen and felt, but what everyone else will think and say in the future*, wrote Tolstoy. The two men never met, though Tolstoy discovered in Ruskin's writings proof of a kindred spirit, a man who could appreciate the virtues of the peasantry, those happy folk who were simpler, humbler and less socially advantaged than oneself. Tolstoy paid a visit to England in 1860–61, as part of a European tour to investigate educational methods. He was planning to set up a school on his estate for the children of his serfs. The two men really ought to have become acquainted, thought curator and collector Sydney Carlyle Cockerell, because they

had much in common in addition to *a love of Dickens, a mistrust of science, and a readiness to accept the literal words of the Gospel.*

<div align="right">Stuart Eagles, *Ruskin and Tolstoy*, p.12</div>

Totley Ruskin's only genuine hand-to-hand combat with political radicals happened, unsurprisingly, on the outskirts of Sheffield, that most politically incendiary of cities, where, in 1875, he established a museum (see **Sheffield** and **St George's Museum**) to teach the local ironworkers to appreciate the beauty to be seen in a leaf. He also bought 13 acres of agricultural land at Totley, and settled a group of Communists there to work it collectively, and make boots and shoes. Its cost was £2,287 16s 6d. Ruskin's view of what would happen on this piece of hallowed ground was misty-eyed: *We will try to take some small piece of English ground, beautiful, peaceful, and fruitful.* The fractiousness of his tenants would prove to be a source of great irritation, pitting old Tory authoritarianism against a more contemporary brand of political make-believe. The Communists believed in equality, Ruskin in top-down obedience from happy, docile workers. Did they – or did they not – part-own the freehold? Yes, they argued. Certainly not, thought Ruskin. He was the Master, the man with the money. The Communists were eventually ejected, and the farm, in time, metamorphosed into a peaceable market garden.

<div align="right">*FC*, Letter 5, p.101</div>

Travelling Ruskin was forever on the move. Some have calculated that he spent half his lifetime travelling. His intellectual restlessness was matched only by a restlessness of body. Many of his books are extended records, in image and word, of his journeyings, travel writing of an intellectually elevated kind. His father John James (see **Father**) travelled the length and breadth of Britain to sell his sherry. The young John often accompanied him, thereby acquainting himself with country houses, their architecture and their art collections. His father often

borrowed a travelling carriage from Henry Telford, one of his business partners, which afforded splendid views. To the son it was sheer pleasure rather than business. *The old English chariot is the most luxurious of traveling carriages, for two persons, or even two persons and so much of third personage as I possessed at three years old. The one in question was hung high, so that we could see well over stone dykes and average hedges.*

James S. Dearden, *John Ruskin*, p.8

Trees When Ruskin describes the behaviour of a tree, it is as if he is talking about a cat-and-mouse game played between children. Trees behave unexpectedly, waywardly, as if waiting to be chanced upon. *The moment it is looked at, it seems bent on astonishing you, and doing the last things you expect it to do,* he writes in *Modern Painters*, as if almost hushed in its presence. The key to understanding the character and the behaviour of a tree is, of course, close looking. He writes in an awe-struck prose, almost breathlessly revelatory, as if we are at his side, ready to do what he is doing, engaged in parallel acts of discovery: *If you will lie down on your breast on the next bank you come to . . . you will see, in the cluster of leaves and grass close to your face, something as delicate as . . . a mystery of soft shadow in the depths of the grass, with indefinite forms of leaves, which you cannot trace nor count, within it, and out of that, the nearer leaves coming in every subtle gradation of tender light and flickering form, quite beyond all delicacy of pencilling to follow . . . No human work could be finished so as to express the* delicacy *of nature.*

MP, vol.3, pt.4, ch.9, sections 14 and 16

Turner, J.M.W. Ruskin's life as an art critic pivoted about his defence of the reputation of the painter J.M.W. Turner, the son of a London barber and wig-maker, and a man he regarded as *a great natural force in a human frame.* That defence began when Ruskin was 16 years old, with a letter written in response to an intemperate attack upon some of

Turner's paintings by an ignorant man of the church published in *Blackwell's Magazine*. Turner read those words in his defence, and made it clear he had no wish to see them published. Ruskin described his impressions of first encountering Turner in the flesh on 22 June 1840 with great vividness: *I found in him a somewhat eccentric, keen-mannered, matter-of-fact, English-minded – gentleman; good-natured evidently, hating humbug of all sorts, shrewd, perhaps a little selfish, highly intellectual, the powers of the mind not brought out with any delight in their manifestation, or intention of display, but flashing out occasionally in a word or a look.* Were they ever truly intimate? It seems unlikely. Turner was taciturn, guarded. And yet Ruskin proclaimed his genius to the world without fear or favour, bought his work (as his father had done before him – see **Father** and **Collecting Visitors**), and showed it off with great pride to visitors. He was enthralled by Turner's absolute addiction to ugliness. *He could endure ugliness which no one else, of the same sensibility, would have borne with for an instant. Dead brick walls, blank square windows, old clothes, market-womanly types of humanity – anything fishy and muddy, like Billingsgate or Hungerford Market, had great attraction for him; black barges, patched sails, and every possible condition of fog.* What is more, he understood and had a genuine regard for the poor. *He got no romantic sight of them, but an infallible one, as he prowled about his lane, watching night effects in the wintry streets; nor sight of the poor alone, but of the poor in direct relations with the rich. He knew, in good and evil, what both classes thought of, and how they dealt with, each other.* Ruskin described the greatest of Turner's painterly effects in tidal waves of impassioned rhetoric. Ruskin's word-paintings in defence of his hero would never be equalled. No painter before Turner had ever done justice to a mountain or a stone. His virtues were countless – his *earnest desire to paint the whole of nature*; his *tenderness of perception*; his skilful arrangements of nature, which were not so much direct transcriptions – nothing so crude as that – but more *involuntary remembrance* of things seen . . . *an act*

of dream-vision – a phrase which well summarises what Proust thought about Ruskin's prose (see **Proust**). Turner, in summary, *perceived at a glance the whole sum of visual truth open to human intelligence.* Not quite so deserving of praise was the behaviour of the man himself. Did he show much gratitude for the thousands of impassioned words Ruskin poured forth in his defence? No. Turner was not one to dole out thanks. There was acute frustration in that regard – and disappointment with him after his death in 1851. He left Ruskin not a penny in his will – except £20 for a mourning ring, a piece of niggardliness that enraged Ruskin's father. *He has left £1000 to build a monument to himself, & to you who have built a monument to him stronger than brass – not a Sketch.* What Turner did leave behind was the responsibility of dealing with all the work in the chaos of his studio, which proved to be a headache second to none (see **Turner Bequest**).

PRAE, pt.2, ch.4, 'Fontainebleau', section 66;
MP, vol.4, pt.9, ch.9, sections 5 and 7; *MP*, vol.4, pt.4, ch.18, sections 22 and 25;
MP, vol.4, pt.5, ch.2, sections 16 and 17; *MP*, vol.3, pt.4, ch.10, section 3;
letter from John James Ruskin to his son, 31 January 1852

Turner Bequest Ruskin was appointed Turner's executor in 1848, having championed him all his life. In 1852 he resigned but five years later he agreed to deal with the contents of Turner's studio, manual labour of the most exacting kind, which occupied him, on and off, for seven years. It became one of the most challenging and burdensome tasks of his entire life. *Fancy all this coming upon me in an avalanche – all in the most fearful disorder – and you will understand that I really can hardly understand anything else, or think about anything else,* he wrote to Charles Eliot Norton. He had the task of sifting through no fewer than 19,000 pieces of paper, stored in seven tin boxes. The sheets of paper were often worm-eaten, mouse-gnawed, or torn halfway through. Ruskin never wavered in his task. It became a highly personal matter. *Turner was right and true,*

he wrote, *his critics wrong, false and base*. It was as if an attack on Turner was an assault on his own integrity.

CEN, vol.1, p.42, letter of 28 February 1858; *MP*, vol.5, Preface, section 7

Unrealised Project for Children Ruskin only managed to write about 250 books during his lifetime. Here is a very brief account of one that got away, contained within a lecture delivered at the London Institution on 11 February 1884 about calamitous changes in weather patterns during the 1870s: *I believe it will be an extreme benefit to my young readers if I write for them a little* Grammar of Ice and Air, *and I am much minded to put by my ecclesiastical history for a little while, in order to relate what is legible of the history of the visible Heaven.*

Unto This Last Written in 1862, this is one of Ruskin's most influential books. It is also one of his shortest. Like so many of Ruskin's books, it was never finished. It began life as a series of articles. The history of its serialisation was troubled, and its long-term effects upon his ever fragile health and reputation profound. The novelist William Makepeace Thackeray agreed to run it in the *Cornhill Magazine* – he was its editor – in 1860, but the opposition to Ruskin's opinions were so uniformly hostile that Thackeray suspended publication after the appearance of the third instalment. The argument represents a no-holds-barred attack upon the so-called science of political economy, and Ruskin quickly came to be regarded as an enemy so dangerous and so imbecilic that the only solution was to destroy him, as an editorial in the *Manchester Examiner and Times* of 2 October 1860 vehemently argues: *If we do not crush him his wild words will touch the springs of action in some hearts, and before we are aware, a moral floodgate may fly open and drown us all.* The book, which marks a further dramatic shift away from art criticism (see **Gothic**), analyses the excesses of the unbridled capitalism of his day, and defends the fundamental rights of the working man to be treated

justly, and for the needy to be provided for. It seeks to give an accurate definition of the nature of wealth. Nothing is more morally insupportable and fundamentally unfair, Ruskin thunders, than the imbalance of the relations between employer and employee, master and operative. Capitalists display naked self-interest. It is also they who are responsible for unjust wars.

Venice No place was more beloved by Ruskin. And no single city preoccupied him more. *A city of gold* is how he described this fantastical creation, a city paved with emeralds. His prose in praise and defence of the Queen of the Adriatic rose to ever giddier heights. His first visit was with his parents in 1833, when he was just 14 years old, and his last in 1888. Four matters were of importance to him: its painters, its architecture, the character of its people, and the way the great maritime republic had been governed, until Napoleon seized it in 1797, and its independence finally came to an end. Ruskin captured it more benignly than Napoleon, in words, drawings and paintings. After the revolutions in Europe of 1848 had finally been crushed – the valiant republic of Venice under Daniel Manin had been amongst the last rebellious outposts of the Austro-Hungarian Empire to cede back control – Ruskin hurried there with his young wife Effie Gray (see **Gray**), and *The Stones of Venice*, one of his greatest works, was the fullest account of the city's complicated architectural heritage that had ever been written. It became the standard guide for the educated Victorian traveller – Marcel Proust travelled there with a copy (see **Proust**). Ruskin was eager to record details of buildings under threat of so-called restoration – he regarded unsympathetic restoration as destruction in all but name. In the final volume of *Modern Painters* (see ***Modern Painters***), he describes the virtue of the Venetian character. Here was a sea-faring, sea-hardened people toughened by adversity, war-tried, and pious. The great Venetian painters – and there were no greater (see **Tintoretto**) – painted prayerfully, on their knees. The

Venetian mind was realist, universal and manly. And their architecture – the way in which the outsides of buildings were adorned with frescoes and sculptures – demonstrated that art should be a gift held in common by all. What is more, their polity, the way the city had been governed at the height of its greatness, had been a model of justice and virtue.

Verbosity The widely held view is that Ruskin was a torrentially wordy man from start to finish, that he would never use ten words when a hundred might serve just as well. In part, the wordiness of the King James Bible was to blame (see **Bible**). His first sermon was written and delivered when he was a tiny child, and after a visit to church. It ended as follows: *People, be dood. If you are dood, Dod will love you. If you are not dood, Dod will not love you. People, be dood.* And yet this general view of him is not quite accurate. The young man was, generally speaking, wordier and windier than his older self. In fact, his older self often scolded that younger self for those early spasms of extreme verbosity and obscurantism. As a letter writer, he could be much snappier and wittier than when he composed a lecture. Try gargling with this poetically over-egged single sentence in praise of a precipice, for example, in a section of a book, ostensibly about painting, which in its gentle and ever onward meanderings, has made, rather unsurprisingly given Ruskin's general cast of mind, a long, slow deviation in the direction of geology: *Such precipices are among the most impressive as well as the most really danger-ous of mountain ranges; in many spots inaccessible with safety either from below or from above; dark in colour, robed with everlasting mourning, for ever tottering like a great fortress shaken by war, fearful as much in their weakness as in their strength, and yet gathered after every fall into darker frowns and unhumiliated threatening; for ever incapable of comfort or of healing from herb or flower, nourishing no root in their crevices, touched by no hue of life on buttress or ledge, but, to the utmost, desolate; knowing no shaking of leaves in the wind, nor of grass beside the stream, – no*

motion but their own mortal shivering, the deathful crumbling of atom from atom in their corrupting stones; knowing no sound of living voice or living tread, cheered neither by the kid's bleat nor the marmot's cry; haunted only by uninterpreted echoes from far off, wandering hither and thither among their walls, unable to escape, and by the hiss of angry torrents, and sometimes the shriek of a bird that flits near the face of them, and sweeps frightened back from under their shadow into the gulph of air; and, sometimes, when the echo has fainted, and the wind has carried the sound of the torrent away, and the bird has vanished, and the mouldering stones are still for a little time, – a brown moth, opening and shutting its wings upon a grain of dust, may be the only thing that moves, or feels, in all the waste of weary precipice, darkening five thousand feet of the blue depth of heaven.

W.G. Collingwood, *The Life of John Ruskin*, p.14; *MP*, vol.4, pt.5, ch.16, section 21

Verrocchio, Andrea del The 15th-century Florentine sculptor and metalworker Andrea del Verrocchio was one of Ruskin's heroes, and he acquired a rare *Madonna and Child* from Venice, which he gifted to his new museum in Sheffield (see **St George's Museum**). It seemed appropriate: to give a great painted work by a man who was also a metalworker to a museum created for the working men and women of a great city, which had taken pride in its metalwork for centuries. Had not Geoffrey Chaucer name-checked a Sheffield knife in *The Reeve's Tale*? When Ruskin's old college friend Prince Leopold, the haemophiliac son of Queen Victoria, paid a visit to the museum in 1879, Ruskin spent a long time talking to him about the painting, according to a detailed account of the visit that was published in the *Sheffield Independent*: *It was given to me in Venice by a gracious fortune, said Ruskin, to show to the people of Sheffield. Its merits were many, he explained: it shows the reverence that is due both to woman and . . . to Christ. This picture was the answer to an enquiry often addressed to him: What do you want to teach us about Art? It was perfect in all ways – in drawing, in colouring; on every part the artist had worked with*

the utmost toil man could give. In 1975 the painting was sold by the Guild of St George to The National Museums of Scotland to help stave off bankruptcy.

Victorian Church Statuary, An Insult Ruskin's withering response when he learns that yet more Victorian Gothic statuary is destined to adorn – or perhaps deface – the sacred spaces of London: *A gross of kings sent down from Kensington*

> Note added by Ruskin in 1879 to *SOV*, vol.2, ch.4, section 10

Viper *I had an interesting encounter with a biggish viper, who challenged me at the top of the harbour steps one day before my last fit of craze came on. I looked him in the eyes, or rather nose, for half a minute, when he drew aside into a tuft of grass, on which I summoned our Tommy – a strong lad of 18, who was mowing just above – to come down with his scythe. The moment he struck at the grass tuft, it – the snake – became a glittering coil more wonderful than I could have conceived, clasping the scythe and avoiding its edge. Not till the fifth or sixth blow could Tommy get a disabling cut at it. I finally knelt down and crushed its head flat with a stone . . . Ever your lovingest, J.R.*

> *CEN*, vol.2, p.219, letter of 13 September 1886

Visiting Dignitaries In a letter to his father dated 9 September 1851, Ruskin reports pithily on the arrival in Venice of Marshall Joseph Radetzky (its Austrian Governor) and Emperor Franz Joseph: *he and Radetzky went about together looking just like a great white baboon and a small brown monkey; a barrel organ would have made the thing complete.*

> John Julius Norwich (ed.), *Venice: A Traveller's Reader*, entry 208

Wagner's *Die Meistersinger von Nürnberg* *Of all the* bête, *clumsy, blundering, boggling, baboon-blooded stuff I ever saw on a human stage, that thing last night beat – as far as the story and acting went – and of all the*

affected, sapless, soulless, beginningless, endless, topless, bottomless, topsiturviest, tuneless, scrannelpipiest – tongs and boniest – doggrel of sound I ever endured the deadliness of, that eternity of nothing was the deadliest, as far as its sound went. I never was so relieved, so far as I can remember, in my life, by the stopping of any sound – not excepting railroad whistles – as I was by the cessation of the cobbler's bellowing.

<div align="right">Letter to Mrs Burne-Jones, 30 June 1882</div>

Water, Painting of *It is like trying to paint a soul.*

<div align="right">*MP*, vol.2, pt.2, ch.1, section 5,</div>

Waugh, Evelyn, on Ruskin's remoteness *In the vacancies of the adolescent mind mutually contradictory principles make easy neighbours. From Beardsley there was no great distance to Eric Gill, for whose wood-cuts I developed an abiding love. I had no interest in his teaching, preferring Samuel Butler's* Notebooks . . . *as a source of wisdom. I had not read much Ruskin, but I had in some way imbibed most of his opinions; nevertheless I respectfully studied works that would have been anathema to him, and my mind was divided by the knowledge that all that was most admired in modern painting was being done in defiance of his canon.*

<div align="right">Evelyn Waugh, *A Little Learning*, p.122</div>

Whistler, James Abbott McNeill, The Trial In 1877 Ruskin, never a man to be coy with his opinions, attacked a painting by James McNeill Whistler called *Nocturne in Black and Gold* with fury and disgust. He had seen it on display in an exhibition at the Grosvenor Gallery in London. It was the kind of display of intemperance that Ruskin's younger self – the man who had so ably defended his hero, J.M.W. Turner, from similar attacks (see **Turner**) – might have condemned for displaying a mixture of ignorance and hotheadedness. *I have seen, and heard, much of Cockney impudence before now*, he wrote in a *Fors Clavigera* letter dated 18 June

(see **Fors Clavigera**), *but never expected to hear a coxcomb ask two hundred guineas for flinging a pot of paint in the public's face.* Did Ruskin really think that Whistler (an American) was a Londoner? Whistler lashed back by suing Ruskin for libel. Ruskin lost the case (leading to the above statement being omitted from the 1896 collected edition of *Fors Clavigera*), but Whistler's victory proved to be a pyrrhic one: damages of one farthing were awarded. Ruskin's influence was such that during the year before the case came to trial, Whistler failed to sell a single picture. The consequences were profound for Ruskin himself. A cartoon in *Punch* had some fun at the expense of an ageing art critic out of key with the times: he was shown as an *Old Pelican in the Art Wilderness.* (The pelican was the crest of Ruskin's Oxford College – see **Oxford**.) The costs of the trial – £400 in all – were divided between the two parties. Ruskin's friends covered his proportion; Whistler was declared bankrupt within six months. Modernity was manifesting itself in other ways, too, during the year of the Whistler trial. The very first floodlit soccer match took place at Bramall Lane, still the home ground of Sheffield United. It was in Sheffield that Ruskin had recently established his first (and only) museum for the common man (see **Sheffield** and **St George's Museum**).

Quoted in J.M. Whistler, *The Gentle Art of Making Enemies*, Prologue

Wilde, Oscar *The dearest memories of my Oxford days are my walks and talks with you and, from you I learned nothing but what was good. How else could it be? There is in you something of prophet, priest, and of poet, and to you the gods gave eloquence such as they have given to none other, so that your message might come to us with the fire of passion and the marvel of music, making the deaf to hear and the blind to see.* This letter addressed to Ruskin was enclosed in a presentation copy of Wilde's *The Happy Prince* in 1888. Wilde regarded the majesty of Ruskin's prose as a work of art equal to the paintings it described. When at Oxford, Professor Ruskin was Wilde's spiritual guide, and a prompt to good, socially

usefully conduct too. Wilde rose at dawn, with great reluctance, to join the Hinksey road builders (see **Roads**), and was repaid with the privilege of being allowed to fill *Mr Ruskin's especial wheelbarrow*. As their friendship matured, they dined together, and went to the theatre and pantomime. And Wilde's final tribute to his mentor? To plagiarise him, shamelessly, when he came to write his American lectures.

Women We hear much of the role of great men in the works of Ruskin and Thomas Carlyle (see **Carlyle**). What were women good for? Ruskin gives us an answer in a lecture called 'Of Queen's Gardens', which was published in 1865. Having ranged around his wide reading in literature and mythology – Shakespeare, Spencer, Dante and others – he then offers us a list of perfect women. All of them are heroines from the plays of Shakespeare, not a single one of them any particular woman who had lived and breathed on this earth. Women are the embodiment of wisdom, he tells us. They are also subordinate. The man's power is active, progressive, defensive. He is the doer, the creator, the discoverer, the defender. His energy is for adventure, war, conquest. Women's power, on the other hand, *is for rule, not for battle, and her intellect is not for invention or creation, but for sweet ordering, arrangement and decision . . . Her great function is Praise . . . She must be enduringly, incorruptibly good; instinctively, infallibly wise – wise, not for self-development, but for self-renunciation: wise, not that she may set herself above her husband, but that she may never fail from his side: wise, not with the narrowness of insolent and loveless pride, but with the passionate gentleness of an infinitely variable, because infinitely applicable modesty of service – the true changefulness of women*. Ruskin had many regular female correspondents. All dutiful and sweet-natured subordinates? Not at all. What is more, Ruskin was a great advocate of education for women.

Sesame and Lilies, 'Of Queens' Gardens', pp 109–10

Woolf, Virginia, on Ruskin's verbal fountains *The style in which page after page of* Modern Painters *is written takes our breath away. We find ourselves marvelling at the words, as if all the fountains of the English language had been set playing in the sunlight for our pleasure, but it seems scarcely fitting to ask what meaning they have for us. After a time, falling into a passion with this indolent pleasure-loving temper in his readers, Ruskin checked his fountains, and curbed his speech to the very spirited, free and almost colloquial English in which* Fors Clavigera *and* Praeterita *are written. In these changes, and in the restless play of his mind upon one subject after another, there is something, we scarcely know how to define it, of the wealthy and cultivated amateur, full of fire and generosity and brilliance, who would give all he possesses of wealth and brilliance to be taken seriously, but who is fated to remain for ever an outsider.*

<div align="right">

Virginia Woolf, *The Captain's Death Bed and Other Essays*, 'Ruskin'

</div>

Working Men's College During the 1850s Ruskin taught evening classes at the Working Men's College in London, based first at Red Lion Square and later (from 1857) at Great Ormond Street. It was hands-on work into which he threw himself with a characteristic passion. The aim of the college was to offer *to workingmen and others, who could not take advantage of the higher education open to the wealthy, as much of the best academic training as could be given in evening classes, and to combine this teaching with a real* esprit de corps, *based on the fellowship of citizens and the union of social orders*. Ruskin's classes were on a Thursday evening, and he drew in a range of talented young men who would become both his associates and his disciples, such as William Morris (see **Morris**), Edward Burne-Jones (see **Burne-Jones**) and Dante Gabriel Rossetti (see **Rossetti**). Out of it emerged a *nice little book* (as he put it) called *Elements of Drawing* – its continuing usefulness as a teaching aid demonstrates just how seriously he took the work. Master and pupils sometimes went out on sketching excursions at the weekend. *I think you would like to come out*

with one of my sketching parties, Ruskin wrote to the founder of the college. *I am only going to have two more, the next, D.V., on Saturday next. Cabs at Camberwell Green at half past three. Tea at the Greyhound Inn, Dulwich at seven. Come early or late as you find convenient, if you can come at all.* The earliest known caricature of Ruskin shows him leading one of these excursions in his wide-awake hat. It has the following inscription: *We all believe what our leader says. We account him infallible, every word that he says whether it be sense or nonsense has some deep and hidden meaning in it.*

CEN, vol.i, p.40; *Letters from John Ruskin to
Frederick J. Furnivall M.A. and Other Correspondents*, ed. T.J. Wise, p.58

World, The Next *What does it matter what any of us think? We are but simpletons, the best of us, and I am a very inconsistent and wayward simpleton. I know how to roast eggs, in the ashes, perhaps – but for the next world! Why don't you ask your squirrel what* he *thinks too? The great point – the one for all of us – is, not to take false words in our mouths, and to crack our nuts innocently through winter and rough weather.*

HI, pp 29–30

Writing Habits By his own account, Ruskin wrote methodically, patiently, unstoppably, and without the feverish rancour or complaint he associated with the habits of his fellow scribbler Thomas Carlyle (see **Carlyle**). Above all, the work was never drudgery. *My own literary work was always done as quietly and methodically as a piece of tapestry. I knew exactly what I had got to say, put the words firmly in their places like so many stitches, hemmed the edges of chapters round with what seemed to me graceful flourishes, touched them finally with my cunningest points of colour, and read the work to mamma and papa at breakfast next morning, as a girl shows her sampler.*

PRAE, pt.2, ch.7, 'Macugnaga', section 135

Year 1858, The Conveniently placed almost exactly mid-way through his life, the year 1858 marked a break point for Ruskin. Hereafter would

begin his long, and often profoundly troubled, afterlife, so often over-shadowed by illness, uncertainties about his fiercely held views on the relationship between art and religion, the deaths of his parents, ferocious assaults upon his reputation, incipient madness, and the beginnings of a catastrophic amorous attachment to a child of ten years old (see **La Touche**), whose early death would cause him grief unimaginable that endured until his own demise in 1900. The most profound change of all was his break with the kind of evangelical Christianity which had been his succour from childhood on (see **Bible**). That change is marked in a passage from *Praeterita* (see ***Praeterita***), his autobiography, by a description of a revelatory moment in front of a painting by the great Venetian artist Veronese in a gallery in Turin, preceded by a visit to a chapel where a handful of worshippers living their dull terrestrial lives could look forward to nothing but the consolations of the afterlife. Was that quite enough? *I walked back into the condemned city, and up into the gallery where Paul Veronese's* Solomon and the Queen of Sheba *glowed in full afternoon light. The gallery windows being open, there came in with the warm air, floating swells and falls of military music, from the courtyard before the palace, which seemed to me more devotional, in their perfect art, tune, and discipline, than I remembered of evangelical hymns . . . And as the perfect colour and sound gradually asserted their power on me, they seemed finally to fasten me in the old article of Jewish faith, that things done delightfully and rightly, were always done by the help and in the spirit of God . . . There was no sudden conversion possible to me, either by preacher, picture or dulcimer. But that day, my evangelical beliefs were put away, to be debated of no more.*

PRAE, pt.3, ch.1, 'The Grande Chartreuse', section 23

Years of Silence The thunderous prose and the biblical perorations of Ruskin came to a stop in 1889. He did not die until 1900. Much of the last decade of his life was lived in total silence, seated in a favourite

bath-chair in the window corner of his study looking every inch the inscrutable bearded sage, walking the slopes of his steeply upwardly inclining garden on the fells at the back of the house, or occasionally going out rowing in *The Jumping Jenny*, the little boat made to his own design, on Coniston Water in the company of his ever watchful cousin, Joan Severn (see **Severn**). He almost finished *Praeterita*, his autobiography (see ***Praeterita***). Joan did the necessary to bring it to a fairly tidy conclusion. His last contribution to the book, which whirls through and across and around the compactedly dense world of his own memories much like any good prose poem should do, and in a way which Proust (see **Proust**) and perhaps even Ezra Pound would later learn from, reads as follows: *How things bind and blend themselves together! The last time I saw the Fountain of Trevi, it was from Arthur's father's room – Joseph Severn's, where we both took Joanie to see him in 1872 . . . Fonte Branda I last saw with Charles Norton, under the same arches where Dante saw it. We drank of it together, and walked together that evening on the hills above, where the fireflies among the scented thickets shone fitfully in the still undarkened air. How they shone! moving like fine-broken starlight through the purple leaves. How they shone! through the sunset that faded into thunderous night as I entered Siena three days before, the white edges of the mountainous clouds still lighted from the west, and the openly golden sky calm behind the Gate of Siena's heart, with its still golden words, 'Cor magis tibi Sena pandit [Siena opens its great heart to you]' and the fireflies everywhere in sky and cloud rising and falling, mixed with the lightning, and more intense than the stars. BRANTWOOD, June 19th 1889*

<div align="right">PRAE, pt.3, ch.4, 'Joanna's Care', section 86</div>

Ziffern Ruskin's ziffern (a musical instrument rather than a flying squirrel, which is what its name might suggest) resembles a crude, sturdy approximation of a harp-cum-zither made perhaps by some bibulous local carpenter, and it sits on a table top in the parlour of Ruskin's old

home, Brantwood (see **Brantwood**). He had it made to his own specifications so that very young children could enjoy the experience of playing a musical instrument by dragging their fingers across the strings from left to right. Or right to left. Ruskin was not especially pleased by the outcome. It was one of his less successful creative ventures. For all that, he could not quite bring himself to admit that it was a complete failure, as he wrote in October 1884: *[it is] unsuccessful only in that the form of lyre which was produced for me, after months of labour, was as curious a creation of physical deformity as a Greek lyre was of grace, besides being nearly as expensive as a piano.* The Broadwood piano to which Ruskin may be glancingly referring (he owned several) is also at Brantwood, and in the very same room as the ziffern. A handsome, upright *Model no.4 pianette in a rosewood case*, manufactured at the Horseferry Road workshops, London, a label tells us that *on Monday 30 June . . . it was placed in a specially made wooden packing-case, taken by our porter Mr Riches to Camden Station, and sent via London and North Western Railway to Coniston Station, from where it was delivered by horse and wagon to . . . Brantwood.*

Quotes displayed in the rooms at Brantwood where the objects are displayed

ACKNOWLEDGEMENTS

The beginnings of this book were first coaxed into being over several excellent pints of Betty Stogs (4.2%) at the Canton Arms in Stockwell, enjoyed in the company of my friend Martin Caiger-Smith, who runs the curating course at the Courtauld. Martin was working on a big Ruskin show at Two Temple Place in celebration of the Sage of Coniston's bicentenary, and we gassed about the difficulty of bringing Ruskin over now. Why was he so remote from us? How to humour him back to life from that lost world of bewhiskered Victorian sepia?

It helped that I had been born in Sheffield, where Ruskin, that rich idealist, established his only regional museum for the working man. The exhibition itself, at least in part, was designed to put on display the part-hidden riches of Ruskin's great bequest to Sheffield. So I joined the curatorial team of *Ruskin: The Power of Seeing*. Why this book though? Well, there was, I soon discovered, a great deal to be thought and said about a man quite as oddly stimulating as Ruskin, far too much for a mere fistful of text panels, a timeline, and a catalogue essay. Who exactly was this Victorian oddity then? Who was he chummy with? What did he think? How did he disport himself? The answers to all those kinds of questions deserved to be poured into an idiosyncratic bran-tub of a dictionary such as this book became.

Many other people have helped me too, and I shall list their names as they tumble out of the lumpy sack of my mind: Alistair Davies and John Birtwhistle (two brilliant close-scrutineers); Robert Hewison (the

pre-eminent Ruskin scholar of our day whose edited versions of a handful of Ruskin's texts I have made use of in this book); Mick and Kay Walker; Howard Hull (a marvellous host at Brantwood); Judith Bronkhurst; Stuart Eagles; Clive Wilmer (Master of the Guild of St George, poet, and old friend); James Dearden (tirelessly helpful and inexhaustibly knowledgeable about all Ruskinian matters); Simon Seligman; Louise Pullen; Alison Morton; Kirstie Hamilton; David Charleston; Stephen Wildman; and all the wonderfully kind, patient and efficient people I worked with at Two Temple Place. This book could not have been written without all your wise words of guidance, caution and admonition. All the foolishnesses are my own. I also wish to thank Two Temple Place for allowing me to use the *Timeline* I produced for them as a basis for the one in this book. And, last but scarcely least, I must thank my marvellously loving and patient wife, the artist Ruth Dupré, for putting up with me over the few manic months of this writing project.

BIBLIOGRAPHY

The 39-volume *Library Edition of the Works of John Ruskin*, with its excellent indices, can be read online, and entirely free of charge at the Ruskin Collection website at Lancaster University: www.lancaster.ac.uk/the-ruskin/research-and-collections/additional-resources/the-complete-works-of-john-ruskin.

The following is a list of the other principal books and publications (including my own copies of works by Ruskin) that I have used in the course of preparing this dictionary.

RUSKIN'S WRITINGS

Modern Painters [1843–60], 5 vols, Everyman Library, London (2006)

The Seven Lamps of Architecture [1849], George Allen, London (1906)

Pre-Raphaelitism [1851], Waverley Book Company, London (undated)

The Stones of Venice [1851–3], 3 vols, John Ruskin, Everyman Library, London (1907)

The Stones of Venice [1851–3], John Ruskin, edited and introduced by Jan Morris, Bellew & Higton, London (1981)

Giotto and His Works in Padua [1853–60], ed. Robert Hewison, David Zwirner Books, New York (2018)

The Elements of Drawing [1857], Amazon Books (2018)

A Joy For Ever [1857], George Allen, London (1905)

Unto This Last and Other Writings [1860 etc], John Ruskin,
ed. Clive Wilmer, Penguin Books, London (1985)

Sesame and Lilies [1865], George Allen, London (1904)

The Ethics of the Dust [1866], George Allen, London (1906)

The Crown of Wild Olive [1866], George Allen, London (1904)

The Queen of the Air [1869], Chelsea House, New York (1983)

Fors Clavigera [1871], 4 vols, George Allen, London (1896)

Fors Clavigera [1871], ed. Dinah Birch, Edinburgh University Press,
Edinburgh (2000)

*Guide to the Principal Pictures in the Academy of Fine Arts in Venice
[1877]*, Facsimile Publisher, Delhi (2018)

St Mark's Rest [1877–84], Forgotten Books, London (2017)

Proserpina, George Allen, London (1879)

The Bible of Amiens [1880], in *Our Fathers Have Told Us: The Bible
of Amiens*, Forgotten Books, London (2018)

The Storm Cloud of the Nineteenth Century [1884], Pallas Athene,
London (2017)

Praeterita [1885–9], intro. Kenneth Clark, Oxford University Press,
Oxford (1949)

Hortus Inclusus, George Allen, London (1888)

*Letters from John Ruskin to Frederick J. Furnivall M.A. and
Other Correspondents*, ed. T.J. Wise, Ashley Library,
London (1897)

On the Old Road, 3 vols, George Allen, London (1899)

John Ruskin: Letters to C.E. Norton, 2 vols, Houghton,
Mifflin & Company, Boston, Massachusetts (1905)

John Ruskin's Letters to Francesca and Memoirs of the Alexanders,
ed. Lucia Gray Swett, Lothrop, Lee & Shepard Company,
Boston, Massachusetts (1931)

Ruskin in Italy: Letters to his Parents, 1845, ed. Harold I. Shapiro,
Clarendon Press, Oxford (1972)

John Ruskin: Selected Writings, ed. Dinah Birch, Oxford World Classics, Oxford (2004)

John Ruskin's Correspondence with Joan Severn: Sense and Nonsense Letters, ed. Rachel Dickinson, Modern Humanities Research Association / Maney Publishing, London (2008)

BOOKS BY OTHERS

Barnes, Janet, *Ruskin in Sheffield*, Museums Sheffield/Guild of St George, Sheffield (2011)

Bryson, John (ed.), *Dante Gabriel Rossetti and Jane Morris: Their Correspondence*, Clarendon Press, Oxford (1976)

Chaney, Edward, *The Evolution of the Grand Tour: Anglo-Italian Cultural Relations Since the Renaissance*, Routledge, London and New York (1998)

Clark, Kenneth, *Ruskin at Oxford*, Clarendon Press, Oxford (1947)

Clark, Kenneth, *Ruskin Today*, Penguin Books, London (1964)

Collingwood, W.G., *The Life of John Ruskin*, Methuen, London (1900)

Collingwood, W.G., *Ruskin Relics*, Isbister & Company, London (1903)

Cook, E.T. (ed.), *Studies in Ruskin*, George Allen, London (1891)

Cook, E.T., *The Life of John Ruskin*, 2 vols, George Allen, London (1911)

Dawson, Annie Creswick, with Paul Dawson, *Benjamin Creswick*, Guild of St George, York (2015)

Dearden, James S., *John Ruskin*, Shire Publications, Aylesbury (1973)

Dearden, James S. *John Ruskin's Camberwell*, Brentham Press, St Albans (1990)

Dearden, James S., *John Ruskin: A Life in Pictures*, Sheffield Academic Press, Sheffield (1999)

Dearden, James S., *John Ruskin's Guild of St George*, Guild of St George, York (2010)

Eagles, Stuart, *Ruskin and Tolstoy*, Guild of St George, York (2016)

Frost, Mark, *Curator and Curatress: the Swans and St George's Museum, Sheffield*, Guild of St George, York (2013)

Gandhi, Mohandas Karamchand, *An Autobiography or the Story of My Experiments with Truth* [1925–9], Dover Publications, New York (1983)

Gill, Eric *John Ruskin*, Prodesse Publications, Wigan (2007)

Goldsmith, Sally, *Thirteen Acres: John Ruskin and the Totley Communists*, Guild of St George, York (2017)

Haight, Gordon S. (ed.), *The George Eliot Letters*, 3 vols, Yale University Press, New Haven, Connecticut (1954)

Hanson, Bruce, *Ruskin and Gandhi: Makers of the 20th Century*, exhib. pamphlet, Brantwood, Cumbria (1996)

Hewison, Robert, *John Ruskin: The Argument of the Eye*, Princeton (1976)

Hewison, Robert, Ian Warrell and Stephen Wildman, *Ruskin, Turner and the Pre-Raphaelites*, exhib. catalogue, Tate Gallery, London (2000)

Hewison, Robert, *Ruskin on Venice*, Yale University Press, New Haven, Connecticut (2009)

Hewison, Robert, *Ruskin and Sheffield*, Guild of St George, York (2011)

Hewison, Robert, *Ruskin and His Contemporaries*, Pallas Athene, London (2019)

Hill, Andrew, *Ruskinland*, Pallas Athene, London (2019)

Hilton, Tim, *John Ruskin: The Early Years*, Yale University Press, New Haven, Connecticut (2000)

Hilton, Tim, *John Ruskin: The Later Years*, Yale University Press, New Haven, Connecticut (2000)

Hope Scott, Edith, *Ruskin's Guild of St George*, Methuen, London (1931)

Jackson, Kevin, *A Ruskin Alphabet*, Worple Press, Tonbridge (2000)

Lambourne, Lionel, *Victorian Painting*, Phaidon, London (1999)

Levy, David M. *How the Dismal Science Got its Name: Classical Economics and the Ur-Text of Racial Politics*, University of Michigan Press, Ann Arbor (2001)

Lutyens, Mary (ed.), *Effie in Venice: Mrs John Ruskin's Letters Home, 1849–52*, Pallas Athene, London (2001)

MacCarthy, Fiona, *William Morris: A Life for Our Time*, Faber & Faber, London (1994)

Mendelson, Edward (ed.), *The Complete Works of W.H. Auden, Volume 6: Prose, 1969–1973*, Princeton University Press, Princeton, New Jersey (2015)

Meynell, Viola (ed.) *Friends of a Lifetime: Letters to Sydney Carlyle Cockerell*, ed. Jonathan Cape, London (1940)

Norwich, John Julius (ed.), *Venice: A Traveller's Reader*, Constable, London (1990)

O'Gorman, Francis (ed.), *The Cambridge Companion to John Ruskin*, Cambridge University Press, Cambridge (2015)

Proust, Marcel, *On Reading Ruskin*, Yale University Press, New Haven, Connecticut (1987)

Pullen, Louise, *Genius and Hell's Broth: a Tale of Two Guild Artists – Frank Randal and William Hackstoun*, Guild of St George, York (2018)

Pullen, Louise, and Michael Glover, *John Ruskin: The Power of Seeing*, exhib. catalogue, Two Temple Place, London (2019)

Shaw, George Bernard, *The Intelligent Woman's Guide to Socialism and Capitalism*, Brentano's Publishers, New York (1928)

Strachey, Lytton, *Eminent Victorians*, Chatto & Windus, London (1918)

Thwaite, Ann, *Emily Tennyson: The Poet's Wife*, Faber & Faber, London (1996)

Tsutomo, Mizusawa, and Nagayama Takiko (eds), *Ruskin in Japan 1890–1940: Nature for Art, Art for Life*, exhib. catalogue, Ruskin

Gallery, Sheffield, Koriyama City Museum and Museum of
Modern Art, Kamakura (1997)

Waithe, Marcus, *Ruskin at Walkley*, Guild of St George, York (2014)

Waugh, Evelyn, *A Little Learning*, Chapman & Hall, London (1964)

Whistler, James McNeill, *The Gentle Art of Making Enemies*,
John W. Lovell Company, New York (1890)

Whitehouse, J. Howard (ed.), *Ruskin Centenary Addresses, 1919*,
London Centenary Council, London (1919)

Whittick, Arnold, *Ruskin in Venice*, George Godwin, London (1976)

Wilmer, Clive, *'A new road on which the world should travel': John Ruskin,
'The Nature of Gothic' and William Morris*, Guild of St George,
York (2014)

Woolf, Virginia, *The Captain's Death Bed and Other Essays*,
Hogarth Press, London (1950)

INDEX

The following index isn't intended to be comprehensive; instead, its entries aim to compliment and cross-reference the listings in the main text. Please refer to the main dictionary entries first when looking for a particular topic or name.